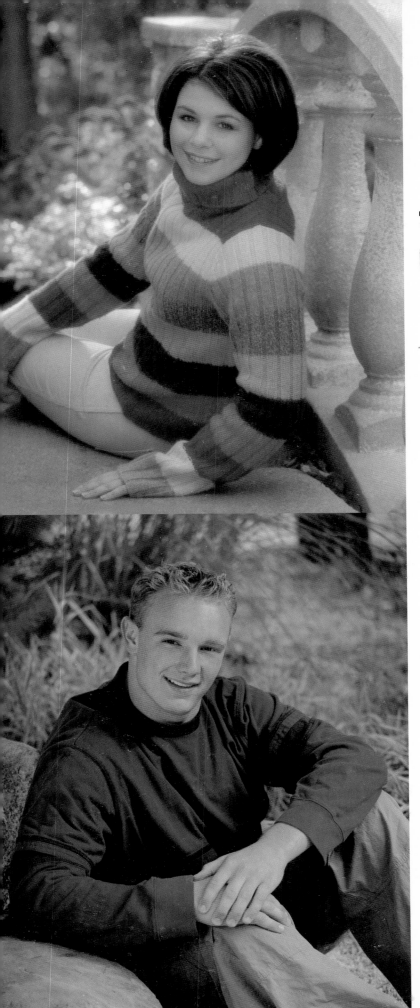

THE ART AND BUSINESS OF

High School

SENIOR PORTRAIT

Photography

Ellie Vayo

AMHERST MEDIA, INC. ■ BUFFALO, NY

DEDICATION

There are several people to whom I would like to dedicate my career and talent. First, I would like to credit my family; my husband, Kevin, for purchasing me my very first camera; my daughters, Rochelle and Erin, who have over the years been beautiful models and appear in this book; and my deceased grandmother, who told me as a child that I could do anything. Last but not least, I would like to thank Jean Truthan, my deceased friend, who inspired me to continue in this field when I wanted to give up. Thank you!

Copyright © 2003 by Ellie Vayo

All photographs by the author, unless otherwise noted.

All rights reserved.

Published by:
Amherst Media, Inc.
P.O. Box 586
Buffalo, N.Y. 14226
Fax: 716-874-4508
www.AmherstMedia.com

Publisher: Craig Alesse
Senior Editor/Production Manager: Michelle Perkins
Assistant Editor: Barbara A. Lynch-Johnt

ISBN: 1-58428-079-4
Library of Congress Control Number: 2002103384

Printed in Korea.
10 9 8 7 6 5 4 3 2 1

770.23
Vayo

Table of Contents

About the Author

▶ CAREER BEGINNINGS

What began as a teenager's hobby grew to become one of the most successful careers one could dream of. As a student at Mentor High School in Mentor, Ohio, Ellie found a love of art. It was there that two art teachers, Ray Lillback and Ken Kary, helped her develop an eye for design that paved the way for a career in portraiture.

Originally, it was interior design that captured Ellie's creative interest—but the minute she picked up her first camera, an Olympus OMI, her focus shifted to photography. Through the camera's eye, Ellie saw things as they should be. She used the camera as a tool to bring out the beauty that people do not always see in the mirror.

The next step was to apprentice for an excellent local photographer, who nourished her

Portrait of Ellie Vayo, courtesy of Craig Kienast.

Reprint from Professional Photographers of America Loan Collection 1999
PPA LOAN COLLECTION
Ellie Vayo Photography • 8358 Mentor Ave • Mentor, OH 44060-6476 • 440-255-7877

Five of Ellie Vayo's images have been Loan Collection prints and have been published in PPA's prestigious Loan Collection book.

desire to learn and allowed her to grow. This training in a studio gave her the time and discipline to develop her somewhat raw talent.

▶ AT PRESENT

It has now been over twenty years since Ellie opened her studio, Ellie Vayo Photography. Since then, the studio has grown into one of the largest portrait studios in the country. While Ellie specializes in several areas, the majority of her business is generated through high school seniors and portraits of underclassmen.

Ellie holds both a Master of Photography and Craftsman degree, as well as a Professional Photographers of America (PPA) certification and Ohio CPP. She has won numerous photographic print exhibit awards, including the J. Anthony Bull Award for the most outstanding portrait in Ohio. Five of her images have been Loan Collection prints and have been published in PPA's prestigious Loan Collection book.

Her most notable contribution to the photography business is the development of the Ellie Vayo Senior Album, through General Products of Chicago. This unique album provides a creative format for the display of previews and pricing information.

Ellie continues to share ideas with her colleagues through her seminars, while keeping up to date on the latest photographic trends and technologies.

Business Basics

▶ GETTING STARTED

One of the most important things that I have learned about getting started in any business is that you have to spend money to make money— you cannot simply wait for business to come to you!

In the early years, when my children were very young, I had no choice but to start a home business. Money was tight and I wanted to be there for my girls. I used a converted two-car garage with a separate entrance as a part-time studio. In the beginning, high school seniors were my forté, and this continues to be the case today.

Since money was scarce, I decided to get acquainted with people already established in successful local businesses. I decided to contact my hairdresser, and offered to photograph the salon's staff and clients at no charge. I then blew up these images to 16" x 20" prints. These images were displayed in the salon for six months. After six months, they were given to the salon free of charge. By doing this, I increased the visibility of my business. I also handed out coupons good for significant savings on packages and prints from my studio to the clients of that hair salon. This particular salon was a high-profile business with a large client base— and as a result of these promotions, my name became known pretty quickly!

As a result

of these promotions,

my name

became known

pretty

quickly!

Next, I designed an inexpensive direct mailer to be sent out to local high school juniors to introduce myself. I purchased a list from the American Student List Company, who supplied pre-addressed mailing labels, making it easy to get the word out. Nearly 300 kids received that first mailer. That first summer, I photographed thirty seniors on a very small budget. The schools were non-contract ones—schools that had not signed with a specific photographer to take student's photos. My package prices were very low because my overhead was very low.

The seven years I spent working from my garage taught me much about the special needs—and perks—inherent in running a home studio.

1. You have to be very disciplined, keeping your business needs in check at all times.
2. Running a home-based business is very personal. I found that my clients loved the easy, laid back feeling I had created in my home studio.
3. Low volume allowed me to get very creative in

Clients can relax and be themselves in the laid-back atmosphere I've created in my studio—and this results in better portraits.

photographing high school seniors.

Unfortunately, there were also disadvantages.

1. Many people felt that since I was a "home" studio my prices should remain low and sometimes would bicker over prices as my business grew.
2. My studio was located off the beaten path. I was simply not located in a well-traveled area, and my business was not as visible as I'd have liked it to be.

3. As my business grew, my neighbors did not like the traffic that I was creating in a residential area.

It took me several years to become well known in my area. My studio started small but, after seven years, I took stock of my business, and decided that it was time to move it to a storefront location. Making a transition to a new location can be risky for small businesses. Franchises are very successful all over the country because people recognize the name and are immediately drawn to that

business. Unfortunately, many mom & pop businesses fail—especially when their proprietors don't understand the needs of their clients or know their area.

Success does not happen overnight. My own photographic skills grew as my business grew and changed over the years. After seven years working from a converted garage and seven years in a storefront location, I finally purchased a historical building in a high-profile commercial area. Good business growth takes time, effort and, perhaps most of all, endurance. This is what I have learned over the years. It is the key to a successful photographic operation!

I recommend that anyone who is starting out take courses in business, make solid business plans, and be prepared to put in much time, effort and endurance. Do not expect to open a studio and have everyone beating your door down! Hard work is the key to any successful operation.

► CONTRACT VS. NON-CONTRACT PHOTOGRAPHY

Every area is cursed with contract schools. How do we handle it? My thought is, if you can't *beat* the school contract, then you may as well *join* it—or forget shooting seniors!

My studio is surrounded by seventeen area high schools. This is a dream for most photographers, but remember—I am also in competition with many studios in my area. Several of these schools are contract schools—they recommend that their students are photographed by their own contract photographer. Because it is illegal to force kids to use the services of a particular photographer, we do shoot some yearbook images for students at these schools (however, each

Creating beautiful portraits that clients love is just one part of building a successful studio—camera skills must be paired with good business skills.

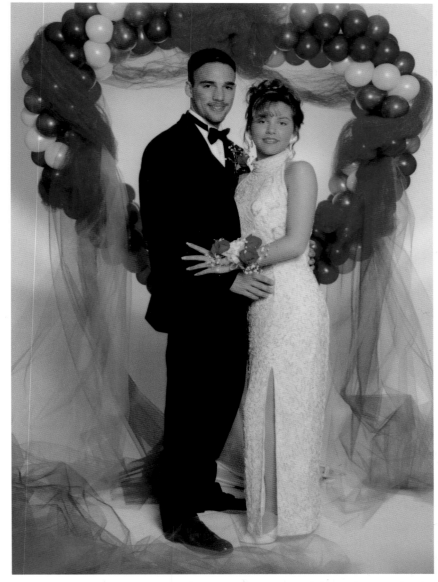

We succeed in shooting a high school's sports and dances simply by getting acquainted with the key people in charge.

ally three per season. We feature kids from local schools in our mailers. Additionally, we run several ads—whether in the yearbook or school newspaper—at the contract schools. We also sponsor special student events. The whole idea behind these efforts is to show our interest and to get acquainted with the yearbook advisor at each of the contract schools.

In truth, though, our biggest success lies in *not* being the contract studio. We succeed in shooting all their sports and dances simply by getting acquainted with the key people in charge. If this isn't happening at your studio, evaluate your networking skills. If they aren't top notch, you may decide that you would be better off sending a spokesperson or a partner to represent you. The more students you photograph in each contract school, the higher the pressure will be on parents to accept your fine photography over the mediocre photography offered by the contract studio.

▶ PRICING INFORMATION

How do I determine what to charge? There are several thoughts on pricing your prod-

yearbook has its own particular guidelines that must be followed, so we have to be sure to get all of the information we need from the yearbook staff). We are also perfectly happy doing noncontract images. Generally, kids do not mind driving to their contract studio

for the "head shot" that will be used in their yearbook, and then coming to us to do a complete indoor/outdoor session for the rest of their portraits.

How do we attract students from contract schools? Mainly by word of mouth. We also do several direct mail pieces—usu-

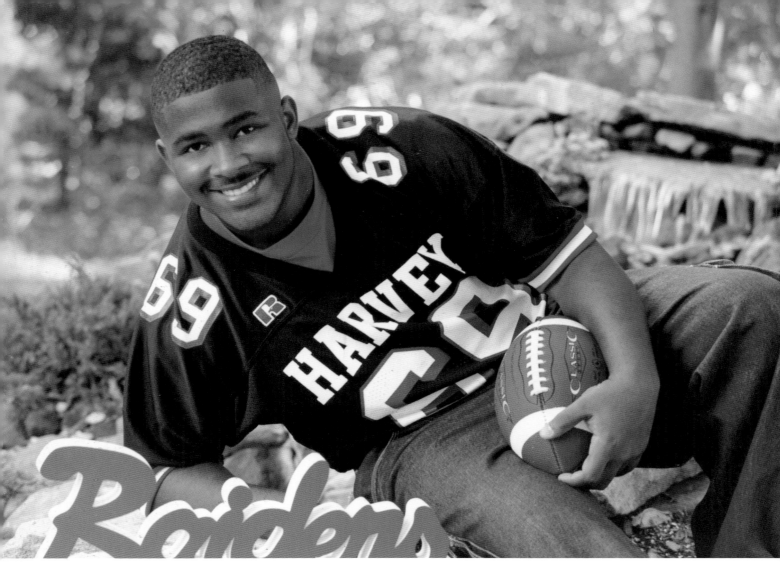

While, as a photographer, your product is artistic, your bottom line is still financial. After all, in order to create images, you have to stay in business!

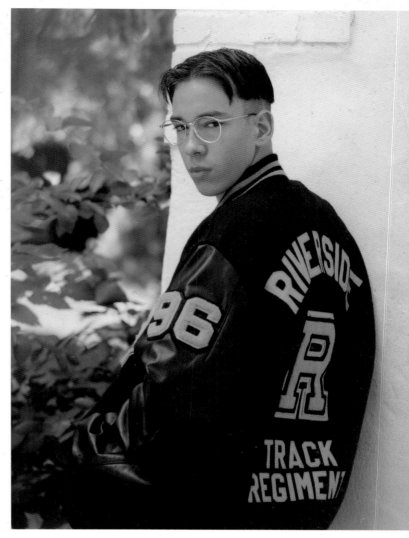

How do you put a price on images like these? Several factors have gone into the development of my pricing strategy, and each is integral to my financial goals.

uct properly. My ideas on pricing are as follows: First, you are in business to *make money*—your goal is to make a good living for yourself and your employees, not to lose money. Second, this is not a hobby. Although I still love what I do, and assume you do as well, the bottom line is financial.

How do you put a price on your product? Through the years, I have set several goals for myself. I have made a long-term plan. Several factors have gone into the development of my pricing strategy, and each is integral to my financial goals. Together, these strategies will enable me to retire early, if I so choose.

My first piece of advice is this: you should never look at what your competition is charging. After all, everyone has his or her own idea about what actually constitutes success. Personally, I want to have a successful business, a beautiful home, nice cars, etc. How do I achieve this? Well, I'll tell you this—I cannot do it by charging $12.95 for one 8" x 10" print unless my volume is *exceptionally* high.

You'll want to consider the following list of questions before you decide on a price schedule for your product:

Before you get behind the camera to begin making images, there are a lot of questions you need to ask yourself—How much money do I want to make as the owner of this business? How many employees do I need? What will I pay them?

1. What do I want to make as the owner? How high will my annual salary be? The first year is usually a baseline for the future years. Always keep records!

2. How many employees will I maintain on a full-time or part-time basis? What will their salaries be?

3. What kind of health benefits will I provide for myself and my employees? What kind of retirement fund will I need for the future?

4. What is my overhead (this includes rent, utilities, all insurances and vehicle use)?

5. How much will I need to spend on camera equipment, new supplies, film, etc.?

Another factor to consider when determining product pricing is the cost of goods versus the charge for the print. For instance, if 300 seniors average $500 a sale, that's $150,000. Thirty weddings at $2500 each totals $75,000. Seventy-five families averaging $500 a sale makes $37,500. That makes the volume of the studio $262,500 for that year. Out of that $262,500, you have to deduct your expenses.

Revenue generated: $262,500

Now calculate all of your costs:

Materials & supplies:
- Folders/albums
- Rebates to schools
- Camera room & outdoor sets
- Color labs
- Shipping & freight
- Film equipment, digital camera, hardware and software

Operating expenses:
- Independent contractor wages
- Part-time and full-time salaries (including your own salary)
- Medical insurance
- Membership costs
- Advertising
- Automobile expenses
- Bank charges, including all fees
- Cleaning
- Donations
- Heating/utilities
- Professional fees (legal & accounting)
- Office expenses (replacing office machines, service repair calls, etc.)
- Rent/mortgage
- Repairs
- Waste removal

The price you charge for your images must be structured to include a lot more than just the cost of your time and film—there are many operating expenses, materials and supplies that also need to be covered.

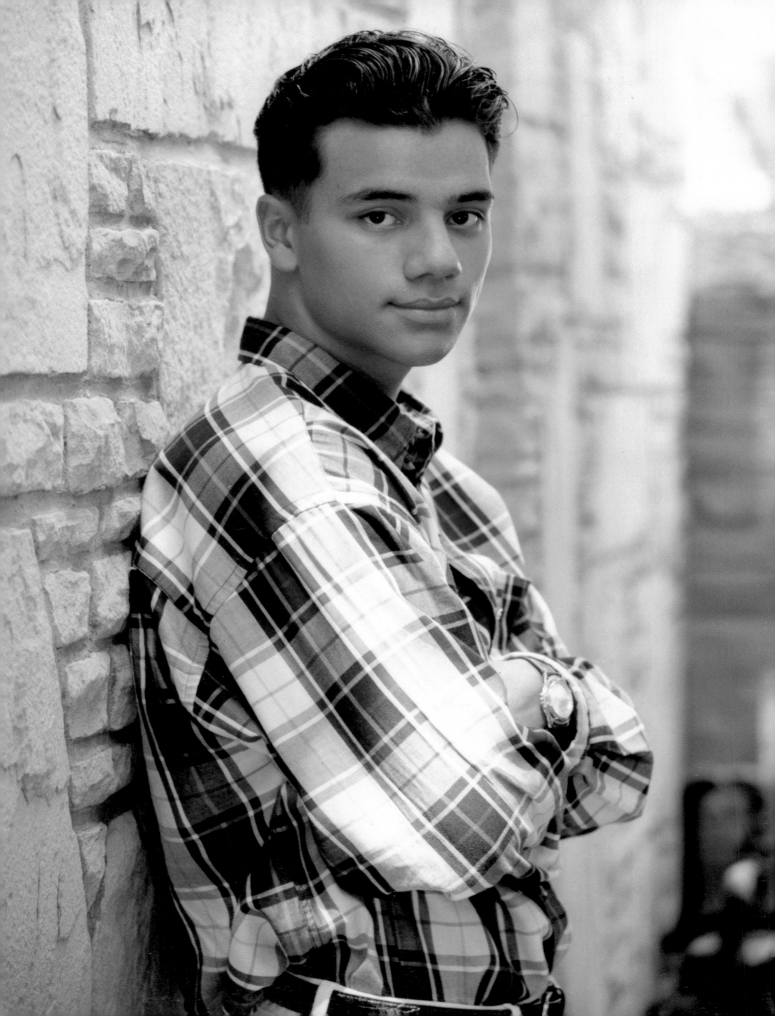

Facing page: Attending seminars and reading photographic magazines will help you to create better images by keeping you on top of the latest artistic styles. It will also help you build your business by learning from the success of others.

- Security
- Supplies
- Telephone
- Miscellaneous expenses (petty cash, coffee, soda, bottled water, etc.)

Subtract your costs from your revenue. Are you showing a profit?

As you can see, there are many costs involved in operating any studio. If the money your studio generates doesn't cover your expenses, you'll find yourself in deep when it comes to debt. While this guide will help you calculate what your costs are, keep in mind that these costs must be based on prices in your area. Also, when figuring your costs, *make sure you include your salary*. Many failing studios don't even pay themselves! You must ask yourself, am I in this as a hobby or as a lifetime career?

► CONTINUING EDUCATION & RESOURCES

One of the most valuable things you can do as a professional is to join your local affiliates as well as state and national associations. The Professional Photographers of America (PPA) and Wedding and Portrait Photographers International (WPPI) will not only help you to expand your talents, but will create the potential for camaraderie with other professional photographers. Another benefit? These organizations have experts on staff that will help you to determine your needs and develop a successful business, so it's best to join early on in your career.

Local seminars are also invaluable. Attending them will help you to stay on top of your field and will subsequently help you to grow your business. The photo industry is changing rapidly as we continue to move ahead digitally. You'll need to stay current to stay on top.

Finally, subscriptions to photographic magazines are also a great source of education. I also find it helpful to subscribe to design magazines—they help me develop creative ideas for implementing new and exciting senior sets.

You must ask yourself, am I in this as a hobby or as a lifetime career?

► MISSION STATEMENT

If your studio does not have a mission statement, then get one! Figure out what your main goals are, what you want to accomplish and what services you want to provide to your clientele. Consider the following points when developing your mission statement, then put them to work!

• Do the best job possible
• Offer only the best quality
• Provide the best in customer service
• Give as much back to the community as possible

► CLIENTS FOR LIFE

Ideally, you want to make each one of your clients a customer for life. We have come to realize that we are not only creating timeless art, we are selling the entire senior experience. At the end of each senior season, you should ask yourself the following questions:

• Why am I in this business?
• Am I selling excitement?
• Do I see financial growth, as well as artistic growth?
• Am I seeing repeat customers?
• Can I be proud of what I have accomplished?

At the end of a photo session your senior client should be so excited about the experience of working with you that he or she can't wait to see the images!

Ideally, you want to make each one of your clients a customer for life.

Advertising

Marketing plays a significant role in the success of any photography studio. After all, if people don't know about your work, they can't purchase it. The first principle to recognize is the age-old cliché that money spent is money earned. Spending money on advertising makes the public aware of your product—and more likely to invest in it. As you budget for advertising, keep in mind that you'll make the most of your money by specifically targeting the audience most likely to make purchases, then presenting them with eye-catching pieces that quickly communicate the nature and quality of your work.

▶ DIRECT MARKETING

When I began Ellie Vayo Photography, I realized that successful advertising was key to developing a successful business. I found that direct marketing, specifically, was the best and most effective way to advertise my home-based portrait studio.

Direct marketing is the most effective method of driving sales. It targets the particular clientele you need to attract in order to help your business grow. Advertising directed at high school seniors should be very visual. We found that when we filled our mailers with colorful pictures of local students, our phones really started ringing, resulting in lots of appointments.

Advertising directed at high school seniors should be very visual.

To this day, and despite the growth of my business, direct marketing continues to be a favored resource. I've learned that if the direct mail piece is eye-catching, the recipient will hold onto it for a very long time. Even if the student doesn't decide to make an appointment immediately, very often he or she will eventually call you to book an appointment.

Through years of research, I have found that direct marketing (if handled properly) will go further than any other means of advertising. Of course, you must handle direct marketing in a smart, cost-efficient way. Begin by looking at all the successful magazine ads and analyzing what makes them work—then bring that insight to your mailers. What elements will you use to catch your client's eye? How will you make sure that potential clients do not throw your ad away? Direct marketing only works when it is eye-catching and easy to read. If your ads do not satisfy these criteria, not only will you fail to get a favorable response (i.e., your phone lines ringing), you'll have wasted your time and money. If your mailer doesn't succeed, you'll need to rethink your mailer's concept and come up with a few new ideas.

Mailers. Many examples of the successful direct-marketing pieces used by Ellie Vayo Photography are shown in this chapter. Looking at them, you can see how they have changed over the years. There is one consistent aspect in all of the pieces, however: they are all eye-catching. After all, we live in a society that bombards us with advertisements—in the mail, on TV, pasted on billboards, on the Internet, etc. If your direct mail piece is to serve its purpose (i.e., interest a potential client), it must grab their attention and hold it long enough to communicate your message. To be successful, marketing pieces should meet the following criteria:

- **Impact.** Your direct mail piece must grab the viewer's attention. This can be accomplished in many ways—with an eye-catching photo, a creative design, a unique color scheme, etc.
- **Style.** Your piece should convey your style—is your work contemporary? Classic? Off-beat? Elegant?

What elements will you use to catch your client's eye?

Spectacular Seniors

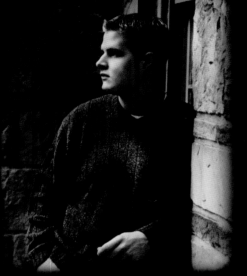

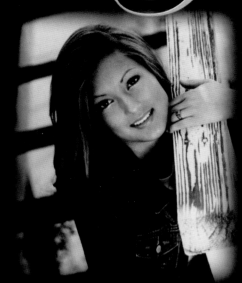

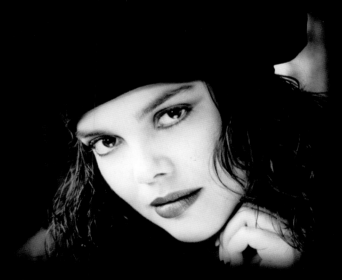

PORTRAITS TO BE
PROUD OF...

ONLY AT ELLIE VAYO PHOTOGRAPHY

A PUBLICATION OF VAYO PHOTOGRAPHY • ALL PHOTOGRAPHS © VAYO PHOTOGRAPHY

INSIDE:

Your Personal Invitation

Let The Excitement Begin
YOUR PERSONAL INVITATION

Dear Parents & Seniors,

Believe it or not, now is the time to start thinking of getting your Senior Portraits taken. *Making an early appointment will allow you to beat the rush and get early savings.*

One of the most important things that you will do in your lifetime is to record these special moments before you leave home. Ellie has been photographing area high school seniors for over 20 years! The Vayo name is well known for high quality, variety and service.

Everything we purchase today...food, cars and clothing is purchased based on name. Ellie Vayo's name is no different! We use state of the art equipment, the highest quality film and paper to assure that your portraits will last forever and our prints are *lifetime guaranteed!!*

Remember! Ellie will be personally photographing each session!

Ellie is known internationally for her work and is a leader in the industry. Ellie and her staff now travel throughout the country testing new film and teaching photographic skills and techniques to her colleagues!

Remember, we are not a part time small operation! Ellie has a full time staff ready to assist you. *We want your Senior Experience to be remembered forever!*

Stop by now to see our Spectacular Senior Video, *book your appointment* and pick up a *free* Senior T-Shirt!!

Sincerely,
Your Friends at Ellie Vayo Photography

Professional Photographers of America
THE WORLD'S GREAT STORYTELLERS℠

2

TOLL-FREE APPOINTMENTS 1 • 800 • 924 • 5238
LOCAL & INFO 255 • 7877 www.evayo.com

Don't listen to us.

LISTEN TO FORMER GRADUATES

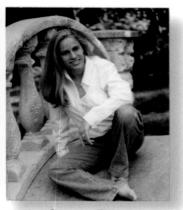

OLIVIA DICK
HAWKEN HIGH SCHOOL

"I loved the encouragement
from Ellie, the attitude, it was
fun from every aspect."

JUSTIN LACAVA
CHARDON HIGH SCHOOL

"The Photo Session was fun
and quick and it was hard to
choose because there were so
many good poses."

COLLEEN DiFONZO
MAYFIELD HIGH SCHOOL

"Ellie and her staff were
really professional and they
had a great makeup artist
to do my makeup!"

DONNETTA GAMBLE
NORTH HIGH SCHOOL

"Everyone was really nice and
gave me personal attention making
this a great senior experience"

MERCEDES IVEY
EUCLID HIGH SCHOOL

"Everyone at the studio was so
nice. Ellie made me feel very
comfortable. I'm glad I came
here for my senior pictures."

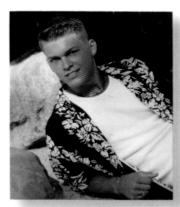

ADAM KASTNING
MENTOR HIGH SCHOOL

"Mrs. Vayo has photographed
my family for years and we've
never been unhappy!"

TOLL-FREE APPOINTMENTS **1 • 800 • 924 • 5238**
LOCAL & INFO **255 • 7877** www.evayo.com

Coupons

You don't have to go anywh...

Check out our Park Setting!

- Wa
- Bea
- Sto
- Wh

ALL THESE POSES WER

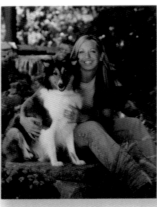

JOANNA HOWE
PERRY HIGH SCHOOL
Waterfall

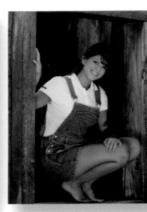

JAMI JOHNSON
MENTOR HIGH SCHOOL
Barn Scene

ROCHELLE VAYO
MENTOR HIGH SCHOOL
"Our Outdoor Park Setting"

Our prints are
LIFETIME GUARANTEED

4

e for great portraiture...

On site
Garden
s/Arbor

- Alley Looks
- Barn
- Gazebo
- Street Scenes

EN AT OUR STUDIO!

ERIN GRAY
SHTABULA HIGH SCHOOL
Garden Area

MEGHAN BEECH
MENTOR HIGH
Arbor Area

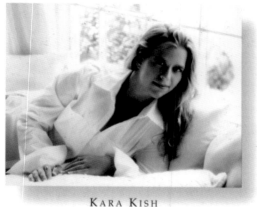

KARA KISH
MENTOR HIGH SCHOOL
Our Window Seat

Please remember most schools accept our yearbook glossies, but also be aware most schools have *early yearbook deadlines!* Schedule your appointment early with us from May through August so that your time slot is guaranteed. Your previews will take approximately 1-2 weeks to be printed. Finished orders can take 8-10 weeks to be completed during our busy season.

Note: Quality portraiture does not happen overnight. Yearbook glossies can take 4-6 weeks to be printed during our busy season. Timely payments are available.

No one else will actually guarantee that you'll like your portraits. But then, no one else has portraits like Vayo's, either!

YOU'LL LOVE YOUR PORTRAITS.

The biggest fear many seniors have is "What if they don't turn out?" After all, you don't get to see the results until after you've paid your money!

The staff of Vayo Photography want to put your mind at ease. They're so confident you'll be thrilled with your portraits, they have the only Satisfaction Guaranteed promise in the business.

IMPORTANT: SCHOOL YEARBOOK GLOSSY DEADLINES*:

	You need to be photographed by:	to guarantee delivery by:
West Geauga	September 15	September 24
Ashtabula High	September 22	October 1
Mentor High	October 1	October 15
Chagrin Falls High	October 1	October 17
Harbor High	October 15	October 29
Harvey High	October 6	October 30
Madison High	October 20	November 1
Riverside High	October 20	November 1
Cornerstone	October 25	November 21
Fairport High	October 21	November 7
St. Peter Chanel High	October 21	November 20
Perry High	October 27	November 24
Kenston High	October 27	November 24
Chardon High	November 20	December 15
North High	November 20	December 6
South High	November 20	December 6
Ledgemont High	November 1	December 14
Geneva High	November 1	December 14
Gilmour High	November 20	December 15
Andrews	November 20	December 15
Berkshire High	December 10	January 19
Edgewood High	December 5	January 15
Kirtland High	November 10	November 30

*Please be advised schools can change these deadlines without any notice.
*Based on last year's deadlines.

Satisfaction Guaranteed

5

Senior Session Styles

Get an early start!!
Build your own session!
Combine any style!

SESSION STYLES

Call now
440-255-7877 or
Toll Free 800-924-5238

Prime spots are filling fast!!

On Location - 24 to 30 poses including 10 indoor at the studio. On location at the Beach, your Home, Barn, Boat, Park, etc.. (within 10 miles radius)
3/4 hour at the studio and 1-1/2 hours at your location
Up to 5 outfit changes

Senior Plus - Our best for the Senior Girl interested in the best we have to offer. The session begins with your make-up application in which we apply the correct colors and amounts for your photography session. Now, on to the portrait session you'll never forget. We'll photograph up to 30 poses in a variety of indoor and outdoor settings. Special poses with unique lighting and props that anyone serious about photography will appreciate.
1-1/2 hour session
Up to 5 outfit changes

Black & White Color Combo - This session combines the best of indoor/outdoor as well as black and white. Includes up to 18 color indoor and outdoor poses plus up to 6 Black & White poses.
1 hour session
Up to 4 outfit changes

An all around favorite!

Indoor/Outdoor - An all around favorite! Up to 24 poses at our studio in a variety of classic indoor and actual outdoor photography. Personalize your session with your instrument, sport uniform, car or friends at no extra charge. *(Note: Pets are extra.)*
1 hour session
3 to 4 outfit changes

Indoor Deluxe - This is our expanded version of our Basic Indoor session. Up to 24 poses in a variety of indoor poses from traditional classics to casual hi tech fun.
3/4 hour session
3 to 4 outfit changes

Basic Indoor - This session is up to 16 poses from a choice of backdrops in our classic studio settings. This session mainly concentrates on head and shoulder shots.
1/2 hour session
1 to 2 outfit changes

Outdoor Only - This is an outdoor only session. We'll photograph 8 actual outdoor poses.
1/2 hour session
1 to 2 outfit changes

Step out our back door into our own Park Settings.

6

SENIOR PORTRAITS "HELPFUL HINTS"

What Do I Wear?

When choosing your outfits, keep in mind the most important thing is that you like them. You'll want to bring as much variety as possible. Most seniors choose some casual and some dressy outfits. Avoid sleeveless or very short sleeves, because upper arms can be very distracting, especially women.

Guys - for the more traditional portraits, a suit or sport coat with tie is good. Medium to dark sweaters photograph well. For casual and outdoor photos, comfort is the rule - jeans, shirts, sweaters, shorts, sweatshirts, western.

Girls - bring the colors and outfits you feel best in. Dresses, (even formals), sweaters and lace for a more traditional look. Bright colors, patterns, skirts, jeans, shorts. If you like an outfit, it's probably because you look good in it, so make sure you bring it! All White is great for special high key effect. White is a strong color and is great when used properly with a white background. Blonde or light hair looks great with white clothing.

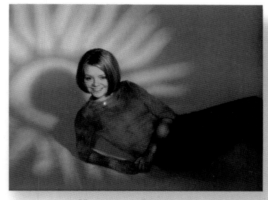

HEATHER PITORAK
NOTRE DAME

Shoes - Often shoes will show so they should compliment your clothing; changes may be necessary with different clothing styles. Many prefer barefoot poses.

What Else Can I Bring?

Here's where the fun really begins! Part of what makes Ellie Vayo Photography so much better is that we work very hard to bring out the various facets of your personality. So make sure you bring you favorite hat, musical instrument, pet, sunglasses, hobby, letter jacket, wheels, uniform, sports activity, or *anything* else you feel would show off the *real you.* Don't forget summertime activities, too: swim suit, boom box, fishing or skiing gear. Also, if you have a telephone in your room, bring it. No idea is too crazy, and since we'll only try a few poses with it, you have nothing to lose– so go for it!

Can I Bring Someone With Me?

Absolutely! Some people find it more comfortable to bring Mom or Dad, a friend, brother or sister along to help ease the "camera room jitters". You are welcome to bring someone with you.

Do You Have Drapes?

We have several sizes, styles, and colors available for use. These add a nice elegant look when used with soft focus.

What About A Suntan?

Too much sun darkens your skin unnaturally, drys out your hair, makes skin appear shiny and greasy and shows bags under your eyes. Strap marks will show as white marks on draped poses or bare shoulder poses. These cannot be retouched. Keep your tan even. Don't overdo the sun for a portrait, it looks great, but use in moderation. Sunburn is a real problem - cancel your appointment if burned.

What About My Hair, Make-Up, Glasses?

Hair - try to have your haircut and/or perm at least one week before your session, to give it a chance to "fill in" a little. Don't try a radically different haircut or style - chances are you won't feel it expresses the "real you". Don't cut it until you have seen your previews too.
Make-Up - (Guys, too!) Here's a quick hint that will gently enhance your portraits: Just before your session, stand two feet in front of your mirror. Dab a small amount of cover-up make-up on any noticeable blemishes. That's it - if they're gone in the mirror they'll be gone in your photographs!

Glasses - if you wear glasses most of the time, you'll want to wear them in your portraits. To eliminate glare or reflections call your optician and arrange to borrow a pair of empty frames like yours, or have the lenses removed from your own glasses. Most opticians will gladly do this for free (make sure you give them plenty of notice, though.) This totally eliminates glare and distortions and is the most important way to improve your portraits if you wear glasses. It doesn't take much effort - and it sure makes your pictures look better!

Note: We employ licensed make-up artists.

Prime Appointments are filling fast ... call 255-7877

"Helpful Hints"
Senior Portraits

BLACK & WHITE PORTRAITS

We are proud to offer dramatic Black and White portraits for even more variety. We will ask your permission in a make-up application for Black and White photography. It's quite different than color make-up. Please bring any special outfit that you would like to be photographed in. We suggest any dark outfit with patterns or designs/and white. Several outfits will be available at the studio for you to choose from also. Jean jackets make an excellent choice for clothing. Have fun with this session because it is meant to be an image session. Unless otherwise requested, all poses will be of a head and shoulder type because the make-up application is in contrast to your regular skin tones. Be creative with this session. Let go and create the "Hollywood" that is in all of us.

What Can I Expect At My Photo Session?

First, expect to have a great time, because you will! It's OK to be a little nervous at first, but you'll soon relax with our easy-going manner and super creative photography!

Plan on arriving 10 to 15 minutes before your scheduled time to freshen up and check your outfits. We will spend a few minutes with you to find out which photographic styles you like best. Remember, we want you to have fun - and being late will only result in you feeling rushed and less time spent on your photography.

Bring your favorite music, we have a CD and tape player in the camera room, and we like all kinds of music. So bring a tape or CD or pick from our CD collection.

Be sure to wear one of your outfits to the session to save time. Pick the one that you consider most traditional. It's OK to bring more than the recommended number of outfits if you're not sure what would look best - we will help you pick the most photogenic one.

Please remember your session fees - cash, checks, Visa, Mastercard, American Express and Discover accepted.

If you're unsure of something or have any questions before or during your session, *please ask!* We want you to feel comfortable so you can get the *best portraits* of your *lifetime!*

We are famous for our
"Pre-Portrait Consultation Sittings"
Stop in Anytime!

SUZI TOTH
"DYNAMIC BLACK & WHITE"

CHECKLIST TO BRING:

- hat
- uniform
- instrument
- sports outfit/equipment
- sunglasses
- swim suit
- stuffed animals
- hobby
- session fee
- me stuff
- posters

- telephone
- pet
- shorts
- sun outfit
- dress glasses
 borrow empty frames
- make-up
- belt/shoes
- suspenders
- "wheels"
- other

Black & White Portraits

8

Our special gift to your family.

FAMILY PORTRAIT BONUS

Chances are you have been "planning on having a family portrait made", but just "haven't got around to it yet". Sound familiar? Well here's a great chance for you to get 'em all together! As the family of a Vayo Photography senior you are entitled to a *complete family portrait session at no charge.* And, this is not some cheapie, in-and-out-the-door picture, but rather our very best $85 all-inclusive portrait session.

We'll begin with a personal pre-portrait design consultation to discuss clothing, location and the portrait styles you like best. We'll create your family portrait anywhere you like — in the comfort of your own home or yard, our outdoors or other location or in-studio.* And, we'll photograph any combination of family members you like including the entire group (even with the family pet!), kids alone, Mom and Dad, or grandparents, all at no extra charge.

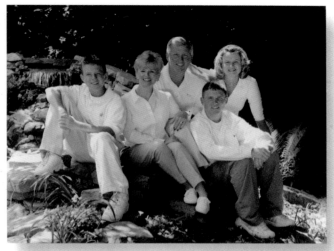

THE DIETZEL FAMILY

Worried about choosing the best pose? No problem! You'll see your originals in the studio via our special projection system. This allows you to see all the details in your children's expressions and we can project to the exact size that would look best in your home. It's neat!

Be sure and take advantage of this special offer. It's a great time to "get 'em all together" and get a head start on your holiday gift-giving!

*There is an additional fee when shooting off location.

IT CAN HAPPEN!

And it can happen to you! Last year there were a number of seniors who came to us after having their portraits taken at other studios – unhappy for whatever reason. Remember, your senior portraits are forever! Don't accept portraits you're not happy with. Have them done over.

Still can't get satisfaction elsewhere?
Then give us a call. If you bring us a copy of your session price sheet from the studio you're not satisfied with, we will subtract that amount from your portrait order at Ellie Vayo Photography. We guarantee your satisfaction!!

Call us today at 440-255-7877!
You'll be glad you did.

TOLL-FREE APPOINTMENTS 1 • 800 • 924 • 5238
LOCAL & INFO 255 • 7877 www.evayo.com

Family Portrait Bonus

Ellie Vayo Photography Inc.

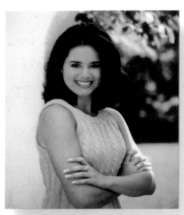

ROCHELLE VAYO
MENTOR HIGH SCHOOL

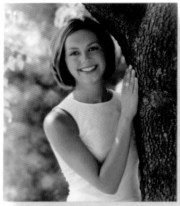

RACHEL SCHOEPPLER
SOUTH HIGH SCHOOL

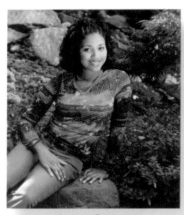

ABRA SMITH
EUCLID HIGH SCHOOL

BRIAN BALDACCI
WEST GEAUGA HIGH SCHOOL

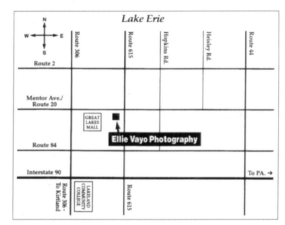

Lake Erie

Professional Photographers of Amer
THE WORLD'S GREAT STORYTELLE

Certified Professional Photographers of Ohio

Do this right now:

Three easy steps to great senior portraits:

First - Before you call: Check out all the sitting choices to see which one you'd like. You need to pick your sitting before you call so we can schedule enough time to do a great job without rushing you.

Next - Pick up the phone and dial 255-7877 for your appointment time. Many time slots are already taken, and it won't be long before they're gone entirely (last summer, every available appointment was filled.) Be sure and think about your school's yearbook deadline, when scheduling your appointment. So don't put it off any longer!

Then - Kick back and relax! We'll do our absolute best to prepare you for your sitting. You'll get a brochure in the mail that gives you all the details on how to plan for a great portrait; what to wear, what and who to bring, how to find us and many other helpful hints. You'd expect help this good from the senior portrait leaders, and you'll get it -Vayo … for seniors with class!

Call Now 440-255-7877

Ellie Vayo

Ellie Vayo
Photography Inc.

8358 Mentor Avenue
Mentor, Ohio 44060
(3 Buildings West of Rt. 615)
1-440-255-7877
1-800-924-5238

TO THE PARENTS AND:

PRSRT STD
U.S. POSTAGE
PAID
MENTOR, OH
PERMIT NO. 445

Make your appointment online @ www.evayo.com today!

30

- **Professionalism.** Whatever your style, your marketing pieces should appear polished and professional. If you are not experienced with graphic design, consider consulting a professional, or collect and use ideas from other direct marketing pieces you like.

- **Samples.** Your direct mail pieces should feature portraits created for your studio's past clients (it is important to display your own work—do not use stock photography). The images you select should be your best, highest quality portraits—portraits that tell clients you produce excellent work. It's important that the reproductions of the images in your mailer reflect the quality clients can expect in their finished products.

- **Easy to Read.** Don't bog your audience down with too much text, or text that is hard to read. Get to the point, and provide readers with enough information to spark their interest, then tell them how to contact you in order to learn more. Select simple fonts and text color(s) that contrast with the background (black on white is much easier to read than yellow on white, for example).

Mailing List. My studio now mails to twenty-three different high schools within a fifty-mile radius. Studies have shown that the further a client travels, the better the sale will be. Why? Well, we have found that clients who are willing to travel are looking for something different—something they were unable to find at any one of their local studios. Sometimes our mailers change hands—we get referrals from clients and ultimately reach relatives, friends, etc. Our long-distance clients travel twenty miles or more and spend an average of $1000 or more on a single order!

There are several mailing list companies out there that can provide you with a CD filled with potential clients' names and addresses—or address labels with the same information (we use American Student Lists—see the appendix for contact information). These companies research how to best target the students and areas that you want to attract. They will use their expertise to help you market to your area, making your job much easier. Most companies charge a set price for a list of the names and addresses of 100 students, but the more students you mail to, the cheaper the list. Ordering lists that are sorted by zip code will help you target clients within an appropriate radius of your studio, and will also help you save money.

Each year we also make sure to renew our third-class mailer permit, which greatly discounts our mailings and makes communicating with our potential clients more economical. Information on mailing permits can be obtained by calling the U.S. post office at (800)ASK-USPS, or you can visit their web site at www.usps.com.

Past clients' files should also contain information about any

MAILING SCHEDULE

Your first mailing should be sent in April (of the year before the student's senior year), and subsequent mailings should be sent out every four weeks or so.

younger siblings with upcoming graduation dates. For this reason, when generating your mailing lists, be sure to tap into your records. After all, once you've had a successful session with one member of a household, you'll likely get a great referral and can easily add to your client base.

First Mailing. Your first direct mailing can be sent to the parents of potential senior-portrait clients as early as the spring *before* the students' senior year. This informative guide should address questions and concerns, and serve as an educational tool for parents who have never purchased senior portrait photography before. Our guide (see pages 33–34) is sent to about 5,000 parents. It provides a brief discussion on many of the topics that parents and students are concerned about, including information on using noncontract studios, making submissions to yearbooks, scheduling and more.

We also enclose a coupon (shown to the left) with this mailer. This coupon, outlining early-bird specials, offers significant savings for those who act fast and book early sessions. Not only does this encourage parents to act right away, it also generates a cash flow in late April and early May, when the studio is coming out of winter—a slow portrait season.

8358 Mentor Avenue
Mentor OH 44060
440.255.7877
1.800.924.5238
www.evayo.com

Ellie Vayo Photography Inc.

Early Bird Special!!!

If you are Photographed: | **You receive:**

April 16 - April 30

75% off photo session
16 **free** wallets
(with your order)
10% off of last year's
package prices

May 1 - May 15

50% off photo session
8 **free** wallets
(with your order)
5% off of last year's
package prices

- All sessions must be prepaid!
- Mention this flyer when making your appointment.
- Please, bring this flyer to your photo session.
- Orders MUST be placed no later than **June 30, 2001**.
- Photo session to be done on studio premises personally by Ellie Vayo.

**There will never be an offer like this again!
Call now! Spaces are limited!
440-255-7877**
Cash, Checks, Master Card, Visa, Discover and Am. Express

A coupon accompanying our first mailing offers significant discounts to clients who act right away and book an early session.

A PARENTS

Information Guide

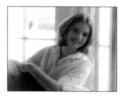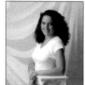

TO SENIOR PORTRAITS
Step-By-Step Suggestions
To Help You Avoid Costly Mistakes
In Choosing Your Senior Photographer

Ellie Vayo
Photography Inc.

8358 Mentor Ave. Mentor OH 44060 255-7877

Dear Parents,

Before you know it, your junior will be a senior, and it will be time to select a photographer for senior pictures. Too often, parents seem to get left out when it comes to making choices about a student's senior portraits. Parents input truly matters and is very important to all of us at Vayo Photography. And it's important to your son or daughter too.

I've prepared this guide to help you be better informed about the senior portrait process, and to help you be a wise consumer. If you follow my tips and suggestions, I guarantee your child's portrait experience will be the best it can be, and you'll be thoroughly satisfied with the results.

If you take away only three things from this guide, let the messages be these: 1) you have the right to pick the photographer of your choice. Therefore you should look beyond the "contract" photographer to be certain you are getting the types and quality of photos you and your senior deserve. 2) The personalized attention and reliable service from the studio staff plays a big part in making your senior's portraits look great. 3) A studio visit would be a very wise investment before you select your photographer.

Sincerely,

Ellie Vayo

 Ellie Vayo
Photography Inc.

8358 Mentor Avenue
Mentor OH 44060
440.255.7877

FOR PARENTS:

10 Steps

TO A SUCCESSFUL SENIOR PORTRAIT EXPERIENCE

Use this guide as a checklist. Progress through the 10 steps, checking off each item as you go…(It works!)

❏ 1. Be involved throughout the portrait process.

❏ 2. Start planning and evaluating photographers now. You can never start too soon. At our studio, the sooner the senior is photographed, the greater the savings.

❏ 3. Don't feel pressured to use the school's contracted photographer. It's simple for your son or daughter to be in the school's yearbook. We submit photos to all area schools.

❏ 4. Visit any studio you are interested in, and look at the portraits they've taken. You'll quickly determine which is best suited to your taste.

❏ 5. Don't limit yourself geographically; don't hesitate to drive a little farther for the photos and service you want. After all, this is a once in a lifetime photo.

❏ 6. Talk with the studio staff and ask questions! Do this prior to the actual photo session!

❏ 7. Evaluate just what you'll be getting for your money. Look for a pricing structure that you are comfortable with. We suggest one that let's you save more as your order increases.

❏ 8. Be thoroughly satisfied with your portraits. If something isn't what you expected, ask why.

❏ 9. Look in the senior section of last years yearbook(s). Look for photographs whose quality stands out. Ask those people where they had their senior portraits taken.

❏ 10. Encourage your son or daughter to be creative and have fun! That's what it is all about.

33

We have the *Answers*

TO YOUR UNANSWERED QUESTIONS

Q A Who should you choose?

One of the nation's finest Senior photographer is in your backyard. For over 20 years, Ellie has been on the cutting edge of creative senior portraits. Ellie lectures at seminars and workshops to keep up with the latest trends in senior photography. She is superb at posing and lighting the high school senior, but one of her best attributes is making the senior feel comfortable in front of the camera.

Q A Why do schools have a contract photographer?

Contracting one photographer simplifies getting photos of dances, sports groups, band groups, graduation, etc. It simplifies it for the school, but it is not necessarily the best choice for students wanting high quality senior portraits. All of our seniors come to us because they choose to. Even if they are contracted to other studios.

Q A Who submits the senior portrait to the yearbook advisor for publication?

We do! We know the specifications and deadlines for submitting yearbook pictures for all of the schools. Senior pictures have been our business for over 20 years. Getting each and every student's yearbook picture delivered on time, and to the right people, is our primary concern.

Q A What makes Ellie Vayo unique?

In our opinion, it is everything we do. From the moment someone calls to make an appointment, to the time they pick up their final order, they will be showered with personal, friendly, helpful service. Ellie knows the importance of senior portraits. Ellie and her associate, Jeanette photograph everyone personally. They have upbeat personalities that put people at ease. The more at ease people feel, the better they photograph!

Q A When should I schedule my senior portrait?

Contrary to what most parents think, **senior portraits are NOT taken in the senior year**! Because the deadline for submitting yearbook portraits is in the fall, most seniors are photographed in the summer before they graduate. If however you are thrift conscious, and want to save a lot of money, schedule your son/daughter to be photographed this April, May, or June. The best buys are before our peak summer season. The earlier your senior is photographed, the more you save. Your son/daughter won't change much between now and July, but your savings will be great. Call us and ask about our Early Bird Specials.

Q A How much should I expect to spend on photographs?

Whether you place a larger order or a small one, you will be amazed at our price schedule. Our pricing is designed so you save more as your order increases.

Pricing is an important issue, but remember, if you choose a photographer who takes mediocre pictures that you are not happy with, any money spent is a waste. Don't let that happen to you!

All of our finished photographs are fully retouched, meaning that we remove blemishes, and soften lines under eyes.

Q A How about a pre-appointment visit to the studio?

We encourage you to stop by for a pre-appointment visit to our studio. During your visit, we will give you a FREE "Senior" T-shirt! We will also give you a tour of the studio, tell you about prices, and answer any questions you may have. Come in for a tour in April, May or June and we will give you a certificate for 8 free wallets (some restrictions apply), even if you schedule your appointment for July or August!

REMEMBER...

Yes, You Can!

Remember, you have the right to select the senior photographer that you want. By law, no individual or organization can tell you where to spend your money.

Your son/daughter's senior portrait is very important. It will follow them for the rest of their life. Consider your options carefully.

Q What if I Have More Questions?

You are important to us. Please call us at 255-7877 and we will answer any questions you may have.

Ellie Vayo Photography

8358 Mentor Ave.
Mentor OH 44060
440.255.7877

34

Second Mailing. The second mailer should be sent sometime in May. When we introduced our second mailer (see pages 21–30 for one example), it pretty much knocked out any competition in the area. This mailer, which is entitled "Spectacular Seniors," is a ten-page piece that has been used in different incarnations for several years (a second example is shown on pages 37–39).

The second mailer is intended for both students and parents. It features eye-catching images and provides answers to frequently asked questions. The ad also includes testimonials (page 3 in our ten-page mailer features several past clients explaining why they enjoyed their sessions with Ellie) and special coupons that serve as an incentive to book sessions at our studio.

While portrait packages are outlined in the second mailer, we do not list prices because, over several senior seasons, prices change. This means we don't need to revise our mailer as often. Also, clients should be lured into your studio because of the high quality of your work—they should come to your studio because *you* are the artist, not just because you offer great prices! After all, how can you put a price on a work of art?

Because yearbook deadlines change every season, it is very important that you develop a relationship with a yearbook advisor in each area high school. It is a good idea to call your area high schools to get information on yearbook deadlines, and to add these dates to your mailers. This will be helpful for parents and seniors who have not gone through the senior portrait routine before. If a school's yearbook deadline is October 15, for example, then the senior must have their pictures taken by October 1. Providing a list of deadlines will

TIPS ON MAILERS

Photographs of your sets should always be included in the flyer. Also be sure to include an easy-to-read map that will lead clients right to your door! Never make mailers too wordy or difficult to read. In addition, because senior portrait subjects are minors, you must be sure that you have the permission of the senior's parent(s) for each image you use in your mailer. It is always best to get this consent in writing.

It doesn't hurt to touch on family portraits in the senior flyers as well. After all, once the parent sees the quality of your work, having a family portrait made might seem like a great idea—especially with a senior who may be leaving the area for college, making future portrait sessions harder to schedule.

Finally, be sure that your mailer includes information on whether or not each particular area school accepts images from your studio for their yearbook. Many contract schools will allow yearbook glossies made at your studio, as long as you stay within their printing guidelines.

PPA has developed an award system (called AN-NE) for outstanding marketing pieces. This group scrutinizes print ads to determine which best serve clients needs, and will help you to determine how the ads can be improved. Our ten-page mailers twice achieved finalist status in competition—and we were the recipient of one AN-NE award.

IMPORTANT: SCHOOL YEARBOOK GLOSSY DEADLINES*:

	You need to be photographed by:	to guarantee delivery by:
West Geauga	September 15	September 24
Ashtabula High	September 22	October 1
Mentor High	October 1	October 15
Chagrin Falls High	October 1	October 17
Harbor High	October 15	October 29
Harvey High	October 6	October 30
Madison High	October 20	November 1
Riverside High	October 20	November 1
Cornerstone	October 25	November 21
Fairport High	October 21	November 7
St. Peter Chanel High	October 21	November 20
Perry High	October 27	November 24
Kenston High	October 27	November 24
Chardon High	November 20	December 15
North High	November 20	December 6
South High	November 20	December 6
Ledgemont High	November 1	December 14
Geneva High	November 1	December 14
Gilmour High	November 20	December 15
Andrews	November 20	December 15
Berkshire High	December 10	January 19
Edgewood High	December 5	January 15
Kirtland High	November 10	November 30

*Please be advised schools can change these deadlines without any notice.
*Based on last year's deadlines.

Providing a list of yearbook deadlines in your mailers will allow your clients to plan ahead and have enough time to choose a yearbook picture without rushing.

also allow your clients to plan ahead and have enough time to choose a yearbook picture without rushing.

For our ten-page mailer, we set aside a budget of $4,500 and printed 10,000 pieces. Once you've decided what type of information you'd like to include in your mailer, and have paid a printer to set up your piece, you can save a template to a CD. This way, if any changes are necessary for future mailings, you can make small adjustments to the ad yourself.

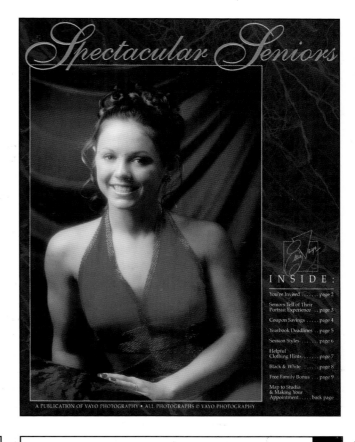

Spectacular Seniors

A PUBLICATION OF VAYO PHOTOGRAPHY • ALL PHOTOGRAPHS © VAYO PHOTOGRAPHY

Your Personal Invitation

Let The Excitement Begin
YOUR PERSONAL INVITATION

Dear Parents & Seniors,
Believe it or not, now is the time to start thinking of getting your Senior Portraits taken. *Making an early appointment will allow you to beat the rush and get early savings.*

One of the most important things that you will do in your lifetime is to record these special moments before you leave home. Ellie has been photographing area high school seniors for over 20 years! The Vayo name is well known for high quality, variety and service.

Everything we purchase today...food, cars and clothing is purchased based on name. Ellie Vayo's name is no different! We use state of the art equipment, the highest quality film and paper to assure that your portraits will last forever and our prints are *lifetime guaranteed!!*

Remember! Ellie will be personally photographing each session!

Ellie is known internationally for her work and is a leader in the industry. Ellie and her staff now travel throughout the country testing new film and teaching photographic skills and techniques to her colleagues!

Remember, we are not a part time small operation! Ellie has a full time staff ready to assist you. *We want your Senior Experience to be remembered forever!*

Stop by now to see our Spectacular Senior Video, *book your appointment* and pick up a *free* Senior T-Shirt!!

Sincerely,
Your Friends at Ellie Vayo Photography

2

Don't listen to us.
LISTEN TO FORMER GRADUATES

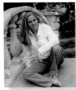

Olivia Dick
Hawken High School
"I loved the encouragement from Ellie, the attitude, it was fun from every aspect."

Justin Lacava
Chardon High School
"The Photo Session was fun and quick and it was hard to choose because there were so MANY good poses."

Brittany Mrsnik
Notre Dame Cathedral Latin High School
"Ellie and her staff knew what they were talking about and selected great poses."

Aimee Earl
South High School
"The Outdoor Settings were incredible. My pictures looked great!"

Erica Grant
Euclid High School
"I liked the pictures of my friends that Ellie did and I knew this was always the place that I wanted to go for senior pictures."

Adam Kastning
Mentor High School
"Mrs. Vayo has photographed my family for years and we've never been unhappy!"

3

37

You don't have to go anywhere else for great portraiture...

Check out our Park Setting!

- Waterfall – On site
- Beach/Rock Garden
- Stone Wall
- White Trellis/Arbor
- Alley Looks
- Barn
- Gazebo
- Street Scenes

No one else will actually guarantee that you'll like your portraits. But then, no one else has portraits like Vayo's, either!

ALL THESE POSES WERE TAKEN AT OUR STUDIO!

Coupons

NO EXTRA CHARGE
One Additional Outfit
$15⁰⁰ Value.
Call Now! **255-7877**
Ellie Vayo Photography • 8358 Mentor Avenue
Only one of these coupons can be used per customer.

SPECIAL • SPECIAL • SPECIAL
$10 OFF
Ready made frame. See our new line!
Call Now! **255-7877**
Ellie Vayo Photography • 8358 Mentor Avenue
Only one of these coupons can be used per customer.

SPECIAL • SPECIAL • SPECIAL
Free Wallet Album
When you place your order. $10⁰⁰ Value.
Call Now! **255-7877**
Ellie Vayo Photography • 8358 Mentor Avenue
Only one of these coupons can be used per customer.

SAVE • SAVE • SAVE
One Free Name Logo
at the time your order is placed
(Valued at $12 - $15)
Call Now! **255-7877**
Ellie Vayo Photography • 8358 Mentor Avenue
Only one of these coupons can be used per customer.

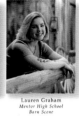

Brenda Butera
South High School
Waterfall

Lauren Graham
Mentor High School
Barn Scene

Kyle Peck
Chardon High School
"The Wall"

Meghan Beech
Mentor High
Arbor Area

Jenn Komar
South High School
"Our Outdoor Park Setting"

Our Prints are
LIFETIME GUARANTEED

Jennifer Salgado
Chardon High School
Our New Window Seat

YOU'LL LOVE YOUR PORTRAITS.

The biggest fear many seniors have is "What if they don't turn out?" After all, you don't get to see the results until after you've paid your money!

The staff of Vayo Photography want to put your mind at ease. They're so confident you'll be thrilled with your portraits, they have the only Satisfaction Guaranteed promise in the business.

SCHOOL YEARBOOK GLOSSY DEADLINES*:

School	Deadline
West Geauga	September 24
Ashtabula High	October 1
Mentor High	October 1
Chagrin Falls High	October 17
Harbor High	October 29
Harvey High	October 30
Madison High	November 1
Riverside High	November 1
Willow Hill	November 1
Fairport High	November 7
St. Peter Chanel High	November 20
Perry High	November 24
Kenston High	November 24
Chardon High	December 1
North High	December 1
South High	December 1
Ledgemont High	December 14
Geneva High	December 14
Gilmour High	December 15
Andrews	December 15
Berkshire High	January 15
Edgewood High	February 12

Please remember most schools accept our yearbook glossies, but also be aware most schools have **early yearbook deadlines!** Schedule your appointment early with us from May through August so that your time slot is guaranteed. Your previews will take approximately 1-2 weeks to be printed. Finished orders can take 8-10 weeks to be completed during our busy season.

Note: Quality portraiture does not happen overnight. Yearbook glossies can take 4-6 weeks to be printed during our busy season. Timely payments are available.

*Please be advised schools can change these deadlines without any notice.
*Based on last year's deadlines.

Satisfaction Guaranteed

TOLL-FREE APPOINTMENTS **1 • 800 • 924 • 5238**
LOCAL & INFO **255 • 7877**

TOLL-FREE APPOINTMENTS **1 • 800 • 924 • 5238**
LOCAL & INFO **255 • 7877**

4 5

Session Styles

Get an Early Start!!
Build your own session!
Combine any style!
SESSION STYLES

Call now
440-255-7877 or
Toll Free 800-924-5238

1/2 Off any Session listed below in the month of May. Beat the Rush!!

A On Location - 24 to 30 poses including 10 indoor at the studio, on location at Headlands Beach or at your Home, Barn, Boat, Park, etc. (within 10 miles radius)
3/4 hour at the studio and 1-1/2 hours at your location **$150.00 plus tax**
Up to 5 outfit changes

B Senior Plus - Our best for the Senior Girl interested in the best we have to offer. The session begins with your make-up application in which we apply the correct colors and amounts for your photography session. Now, on to the portrait session you'll never forget. We'll photograph up to 30 poses in a variety of indoor and outdoor settings. Special poses with unique lighting and props that anyone serious about photography will appreciate.
1-1/2 hour session "New Low Cost" **$80.00 plus tax**
Up to 5 outfit changes

C Black & White Color Combo - **This session combines the best of indoor/outdoor as well as black and white.** Includes up to 18 color indoor and outdoor poses plus up to 6 Black & White poses.
1 hour session **$65.00 plus tax**
Up to 4 outfit changes

An all around favorite!
D Indoor/Outdoor - An all around favorite! Up to 24 poses at our studio in a variety of classic indoor and actual outdoor photography. Personalize your session with your instrument, sport uniform, car or pet at no extra charge.
1 hour session **$50.00 plus tax**
3 to 4 outfit changes

E Deluxe Indoor - This session is up to 16 poses from a choice of backdrops in our classic studio setting.
1/2 hour session **$45.00 plus tax**
1 to 2 outfit changes

F Outdoor Only - This is an outdoor only session. We'll photograph 8 actual outdoor poses from one outfit.
1/2 hour session **$45.00 plus tax**

Step out our Back Door into our own Park Settings.

Prime spots are filling fast. Call now 440-255-7877.

6

SENIOR PORTRAITS "HELPFUL HINTS"

What Do I Wear?

When choosing your outfits, keep in mind the most important thing is that you like them. You'll want to bring as much variety as possible. Most seniors choose some casual and some dressy outfits. Avoid sleeveless or very short sleeves, because upper arms can be very distracting, especially women.

Guys - for the more traditional portraits, a suit or sport coat with tie is good. Medium to dark sweaters photograph well. For casual and outdoor photos, comfort is the rule - jeans, shirts, sweaters, shorts, sweatshirts, woven clothing.

Girls - bring the colors and outfits you feel best in. Dresses, (even formals), sweaters and lace for a more traditional look. Bright colors, patterns, skirts, jeans, shorts. If you like an outfit, it's probably because you look good in it, so make sure you bring it! All White is great for special high key effect. White is a strong color and is great when used properly with a white background. Blonde or light hair looks great with white clothing.

Shoes - Often shoes will show so they should compliment your clothing; changes may be necessary with different clothing styles. Many prefer barefoot poses.

Brittany Price
Mentor High School

What Else Can I Bring?

Here's where the fun really begins! Part of what makes Ellie Vayo Photography so much better is that we work very hard to bring out the various facets of your personality. So make sure you bring your favorite hat, musical instrument, pet, sunglasses, hobby, letter jacket, wheels, uniform, sports activity, or ANYTHING else you feel would show off the REAL YOU. Don't forget summertime activities, too: swim suit, boom box, fishing or skiing gear. Also, if you have a telephone in your room, bring it. No idea is too crazy, and since we'll only try a few poses with it, you have nothing to lose - so go for it!

Can I Bring Someone With Me?

Absolutely! Some people find it more comfortable to bring Mom or Dad, a friend, brother or sister along to help ease the "camera room jitters". You are welcome to bring someone with you.

Do You Have Drapes?

We have several sizes, styles, and colors available for use. These add a nice elegant look when used with soft focus.

What About A Suntan?

Too much sun darkens your skin unnaturally, drys out your hair, makes skin appear shiny and greasy and shows bags under your eyes. Strap marks will show as white marks on draped poses or bare shoulder poses. These cannot be retouched. Keep your tan even. Don't overdo the sun for a portrait, it looks great, but use in moderation. Sunburn is a real problem - cancel your appointment if burned.

What About My Hair, Make-Up, Glasses?

Hair - try to have your haircut and/or perm at least one week before your session, to give it a chance to "fill in" a little. Don't try a radically different haircut or style - chances are you won't feel it expresses the "real you". Don't cut it until you have seen your previews too.

***Make-Up** - (Guys, too!) Here's a quick hint that will gently enhance your portraits: Just before your session, stand two feet in front of your mirror. Dab a small amount of cover-up make-up on any noticeable blemishes. That's it - if they're gone in the mirror they'll be gone in your photographs!

Glasses - if you wear glasses most of the time, you'll want to wear them in your portraits. To eliminate glare or reflections call your optician and arrange to borrow a pair of empty frames like yours, or have the lenses removed from your own glasses. Most opticians will gladly do this for free (make sure you give them plenty of notice, though.) This totally eliminates glare and distortions and is the most important way to improve your portraits if you wear glasses. It doesn't take much effort - and it sure makes your pictures look better!

**Note: We employ licensed make-up artists.*

Prime Appointments are filling fast ... call 255-7877

7

BLACK & WHITE PORTRAITS

We are proud to offer dramatic Black and White portraits for even more variety. We will ask your permission in a make-up application for Black and White photography. It's quite different than color make-up. Please bring any special outfit that you would like to be photographed in. We suggest any dark outfit with patterns or designs/and white. Several outfits will be available at the studio for you to choose from also. Jean jackets make an excellent choice for clothing. Have fun with this session because it is meant to be an image session. Unless otherwise requested, all poses will be of a head and shoulder session. This is because the make-up application is in contrast to your regular skin tones. Be creative with this session. Let go and create the "Hollywood" that is in all of us.

What Can I Expect At My Photo Session?

First, expect to have a great time, because you will! It's OK to be a little nervous at first, but you'll soon relax with our easy-going manner and super creative photography.

Plan on arriving 10 to 15 minutes before your scheduled time to freshen up and check your outfits. We will spend a few minutes with you to find out which photographic styles you like best. Remember, we want you to have fun - and being late will only result in you feeling rushed and less time spent on your photography.

Bring your favorite music, we have a CD and tape player in the camera room, and we like all kinds of music. So bring a tape or CD or pick from our CD collection.

Be sure to wear one of your outfits to the session to save time. Pick the one that you consider most traditional. It's OK to bring more than the recommended number of outfits if you're not sure what would look best - we will help you pick the most photogenic one.

Please remember your session fees - cash, checks, Visa, Mastercard, American Express and Discover accepted.

If you're unsure of something or have any questions before or during your session, PLEASE ASK! We want you to feel comfortable so you can get the BEST PORTRAITS of your LIFETIME!

We are famous for our
"Pre-Portrait Consultation Sittings"
Stop in Anytime!

Suzi Toth
"Dynamic Black & White"

Checklist to bring:

• hat	• telephone
• uniform	• pet
• instrument	• shorts
• sports outfit/equipment	• sun outfit
• sunglasses	• dress glasses
• swim suit	*borrow empty frames*
• stuffed animals	• make-up
• hobby	• belt/shoes
• session fee	• suspenders
• me stuff	• "wheels"
• posters	• other

8

Our special gift to your family.
FAMILY PORTRAIT BONUS.

Chances are you have been "planning on having a family portrait made", but just "haven't got around to it yet". Sound familiar? Well here's a great chance for you to get 'em all together! As the family of a Vayo Photography senior you are entitled to a complete family portrait session at no charge. And, this is not some cheapie, in-and-out-the-door picture, but rather our very best $75 all-inclusive portrait session.

We'll begin with a personal pre-portrait design consultation to discuss clothing, location and the portrait styles you like best. We'll create your family portrait anywhere you like — in the comfort of your own home or yard, our outdoors or other location or in-studio.* And, we'll photograph

The Dietzel Family
"Our Outdoor Park"

any combination of family members you like including the entire group (with the family pet!), kids alone, Mom and Dad, or grandparents, all at no extra charge.

Worried about choosing the best pose? No problem! You'll see your originals in the studio via our special projection system. This allows you to see all the details in your children's expressions and we can project to the exact size that would look best in your home. It's neat!

Be sure and take advantage of this special offer. It's a great time to "get 'em all together" and get a head start on your holiday gift-giving!

**There is an additional fee when shooting off location.*

IT CAN HAPPEN!

And it can happen to you! Last year there were a number of seniors who came to us after having their portraits taken at other studios – unhappy for whatever reason. Remember, your senior portraits are forever! Don't accept portraits you're not happy with. Have them done over.

Still can't get satisfaction elsewhere?

Then give us a call. If you bring us a copy of your session price sheet from the studio you're not satisfied with, we will subtract that amount from your portrait order at Ellie Vayo Photography. We guarantee your satisfaction!!

Call us today at 440-255-7877!
You'll be glad you did.

9

Justin Schultz
Mentor High School

Jessica Svoboda
West Geauga High School

Kylie Suminski
Mentor High School

Kellie Caimi
Kirtland High School

Lake Erie

Professional Photographers of America
THE WORLD'S GREAT STORYTELLERS.

Do this right now:

Three easy steps to great senior portraits:

First - Before you call: Check out all the sitting choices to see which one you'd like. You need to pick your sitting before you call so we can schedule enough time to do a great job without rushing you.

Next - Pick up the phone and dial 255-7877 for your appointment time. Many time slots are already taken, and it won't be long before they're gone entirely (last summer, every available appointment was filled.) Be sure and think about your school's yearbook deadline, when scheduling your appointment. So don't put it off any longer!

Then - Kick back and relax! We'll do our absolute best to prepare you for your sitting. You'll get a brochure in the mail that gives you all the details on how to plan for a great portrait: what to wear, what and who to bring, how to find us and many other helpful hints. You'd expect help this good from the senior portrait leaders, and you'll get it -Vayo ... for seniors with class!

Ellie Vayo
Photography Inc.

8358 Mentor Avenue
Mentor, Ohio 44060
(3 Buildings West of Rt. 615)
1-440-255-7877
1-800-924-5238

To The Parents And:

Call Now 440-255-7877

- **Competition**—Try to forget about the competition and concentrate on improving your own studio. This line of thinking has allowed my studio to shoot about 600 non-contract seniors per season with an average of $600 per order or more.

- **Repetition**—When dealing in advertising, remember the rule of three: people will only remember things after they have heard them at least three times. For this reason, you want all direct mailing pieces to go out at the same time your cable commercials are airing. The more often people see or hear your name, the more likely it is that they will call you when they are ready to get their pictures taken. Make it easy for them to contact you—a toll-free number is a wise investment.

► RADIO ADVERTISEMENTS

Making the move from a business run out of the home to one run in a storefront wasn't an easy change—but it was well worth it. Moving to a storefront was something that I and my staff needed to do to be taken seriously as a business. When we made this move, we contacted a Cleveland radio station about running a promotion. To promote our senior photography, the station broadcast live from the studio and gave away free concert tickets, tapes, free portrait sessions and other goodies. The DJ had all the necessary equipment right at the studio. This promo created quite a stir! Our local police department was notified because the event caused a lot of excitement in our parking lot and it slowed traffic in front of our studio for a couple of hours.

If you are serious about getting your studio's name out, you must set up a budget for advertising. The hard part is sticking to it. This particular radio station provided ten commercials per day for six weeks for about $2,500. Is radio advertisement the best choice for your business? Maybe, maybe not. Combining it with cable advertising, direct mailing and mall displays will attract the greatest number of clients.

► CABLE ADVERTISEMENTS

Our studio was the first in the area to utilize cable television for advertising. To promote our senior portrait photography, we shot two thirty-second commercials to be aired on four cable stations—including MTV. It cost about $1,000 to make the tape, which ran for eight weeks. The commercials ran ten times per day and starred our senior representatives (see pages 42–49). We were able to stick to our budget of $5,000 because the senior reps were so excited to be on TV that we didn't have to pay actors! In the end, the commercials cost around $3.00 each.

In addition to advertising on MTV, we actually added their logo to our mailers, thus drawing the attention of parents and seniors who hadn't even seen the commercials. Seniors and parents might have never heard of Ellie Vayo Photography, but they had been watching MTV for years and now they were associating the two. Putting your studio name in the same

forum as one that already has a customer base and a good reputation can be an enormously successful advertising move.

► DISPLAYS

Display placement is an inexpensive form of advertising. These displays can be located in a mall, an empty storefront, a movie theater, a hair salon, etc. Much of our success in advertising can be credited to this form of visual presentation. When putting a display in a

mall, try to set it up in a place where the upcoming seniors are likely to be—perhaps in front of a music store or popular clothing store. Sometimes you won't have a choice, but if you do—be sure to do your homework. Identify places where the teenagers congregate and set up your display there.

Placing displays in hair salons is also very effective. As noted on page 8, a coordinated campaign to photograph a salon's clients was very suc-

In addition to advertising on MTV, we actually added their logo to our mailers, thus drawing the attention of parents and seniors who hadn't even seen the commercials.

Display placement (in a mall, empty storefront, movie theater, hair salon, etc.) is an inexpensive form of advertising.

cessful for us. The salon chose six men and six women to receive new hairstyles and makeovers. Both black & white and color photographs were taken, and 16" x 20" prints were displayed in matching frames at each stylist's station. The salon passed out coupons to all of their customers who were interested in our photography. For a promotion like this, you should select a busy, high-profile salon and redo the pictures every year or two in order to keep the styles fresh.

▶ HIGH SCHOOL REPRESENTATIVES

A great way to get publicity at local high schools is to have students represent you in return for a considerable discount on their own pictures. Like most people, high school students rely on their friends' opinions as they make a lot of their decisions. This is doubly true for senior pictures. Because of this, getting students to promote your studio and get their friends to come to you is just about the best advertising you can get. It is usually good to get one student representative (or "ambassador") per 100 seniors, so a senior class of 700 would require about seven reps. Fewer reps are needed for smaller classes.

Ellie Vayo Photography has successfully utilized high school senior reps for several years now. There are many advantages to the practice:

• **Increased Public Visibility.** This program helps introduce the studio to new schools and students.

• **Increased Sales.** Last year seventeen representatives produced $105,000 in sales at Ellie Vayo Photography, and referred 175 new seniors!

• **Expanded Markets.** When your studio becomes a common name among high school seniors, it opens the door for you to succeed in other areas of photography. Obviously, the bigger the senior market, the more opportunity there is for you to photograph high school proms and formals, sporting events, etc.

In order to generate interest in the representative program, we sent flyers (see page 43) to students in a high school where we were interested in creating a

TIPS

Because senior representatives graduate every year, you'll need to contact the students and select new reps each year. We determine which students will represent our studio every January. Remember, when looking for new representatives, you'll be dealing with juniors who can begin handing out cards before the end of their junior year and on into their senior year.

To generate interest in the representative/ambassador program in a high school where we were interested in creating a new market, we sent this flier along with our ten-page mailer.

new senior portrait market. The piece was sent along with our ten-page mailer (see pages 21–30 and 37–39). As a result of this mailing, we received about twenty phone calls from students who were interested in the program. Even though this particular school was already contracted to another studio, these seniors and parents still came to our studio.

Once your senior representatives have been chosen, they should be informed of their duties as representatives and understand what they will receive in return for their services. It's a good idea to put together a representative handbook that the students can refer to if they have any questions. A sample of the type of handbook used at Ellie Vayo

Photography is shown on pages 45–46, along with other forms that we use in the representative program.

How It Works. One of the perks of being a student representative for Ellie Vayo Photography is a free indoor/outdoor session. After this session, each of our reps has two powerful tools at their disposal when recruiting potential clients for our studio: (1) proofs from their session to show off, and (2) business cards with their picture on the front and money-saving specials on the back. When the recipient of a business card books their appointment and turns in the card, the new senior saves money—and we have material proof that our representatives have secured a new client for our studio. In addition to their free session, our student representatives also earn points toward some really great prizes in return for their work (see page 47).

The key to success with this program is to find outgoing students that will hand out plenty of business cards—*before* the end of their junior year. It is a common assumption that girls do a better job than the guys

Envelope #:_____

Student Representative Questionnaire

Name:_____ School:_____

Address:_____ e-mail:_____

_____ Phone #:_____

1. Have you been contacted by any other studios to rep. for them?

2. Why would you like to rep. for Ellie Vayo Photography?

3. What will you do that will make you a great rep for our studio?

4. Would you like to be compensated for recommending our studio to your friends and classmates for their senior portraits?

5. What activities or clubs (in or out of school) are you involved in?

6. What do you think of the portraits you see here in our studio?

7. What type of senior portraits would you like to have taken? (For example: outdoor, pets, sports, friends, etc.)

8. What other photography studios have you heard of?

9. Have you seen the work of other studios? If so, what did you like or dislike about it?

10. Can we use your name and number in our mailers to send to your classmates?

Student Representative Handbook for Effective Rewards

As a student representative of Ellie Vayo Photography, you will be given a senior yearbook that contains approximately thirty prints in a variety of poses that you will use to show around your school. You will also be given photo business cards to pass out that offer your classmates $10 off their portrait order. This is a great way to get people excited about their senior portraits!

YOUR PHOTO SESSION

Your photography session is a fun experience that is meant to show variety. Show as many styles as you can think of. Remember your hobbies and interests both in and out of school. Be creative, but don't forget to bring your class ring, letter jacket or uniform! For the black & white portion of your session, be sure to bring clothing that is either black, white, or high in contrast. Please feel free to offer suggestions.

AFTER THE SESSION

We will call you about two weeks after your session to tell you that your prints and photo business cards are in. At that time, please make arrangements to come in and spend 15–30 minutes with us to go over sizes and prices.

PROMOTION

Show your senior yearbook to *everyone*! Some of your friends will like certain styles, and some will prefer others. (That is why variety is so important in your clothing.) As you show the book to your friends, freely pass out your business cards and ask them to consider Ellie Vayo Photography for their senior pictures. Tell them that they are on our mailing list and that they will be getting additional information at home for their parents to look at.

Talk to them about variety in posing, what our studio is like, or even the fun of being treated like a model! Share with them ideas you've seen or even suggest that they have their portraits done in a certain style or with a particular prop.

Tell them about particular sittings available and how they will fit their particular needs. When asked about how much it costs, refer them to us—that's the good part! *Stress the fact that you get what you pay for, and we're one of the highest quality studios in the country today!*

Remind them to bring your photo business card with them when they come in for their appointment. No card, no credit! We will not verbally award you a $15 credit. Tell them that this is our way of knowing that you are doing a good job, and also a tool to evaluate whether the student representative program was effective or not.

Bring them in anytime and let them see the senior slide/video program. This will show them even more variety and give them ideas for their own session!

TIPS FOR REPRESENTATIVES

1. When you know a friend has an appointment, suggest they take a friend with them to share the experience.
2. Remind them if your school will accept yearbook glossies and tell them when their yearbook deadline is.

3. Talk about variety, posing and props.

4. Tell them about our goal to give them the best portrait they have ever had.

5. Tell them that we offer other special promotions, such as wallet specials, friend specials and family specials.

6. You can also hand out your photo business cards to friends from other schools!

BENEFITS OF BEING OUR REPRESENTATIVE

1. Your no-cost session (a $75 value). Please note: any additional sittings will be at a regular cost.

2. You'll receive a senior yearbook and all of your previews at no charge (a $200 value).

3. $15 credit for each photo business card that is brought in to us.

4. $.50 credit for each mailer brought in to us from other studios.

5. A chance for you to be in our color mailers.

6. An opportunity to represent one of the most successful senior photography studios in the country today!

7. A $200 bonus scholarship will be awarded to the rep with the highest number of photo business cards turned in!

Being a rep is like having an exciting part-time job. Senior portraits are fun, and you'll love being involved! If you have any questions, please feel free to call us at (555)555-5555, or toll-free at (800)555-5555.

ELLIE'S CREDENTIALS

Ellie is a member of the Mentor Chamber of Commerce, Professional Photographers of Ohio, Professional Photographers of America, and Society of Northern Ohio Professional Photographers. She has also had two of her award-winning photographs travelling in the Kodak General Loan Collection, and has had both of these published in their Loan Collection books. You can see these books at the studio.

Ellie holds a Masters and Craftsman degree in photography, and now teaches and lectures throughout the country.

TIMELINE

By March 31— have picture taken for business cards

By May 5*— have senior pictures taken

* If you have your senior pictures taken by April 21, you will receive a free facial makeover for your photography session by one of our on-staff makeup artists.

Pro Rewards Program for Student Representatives

You will make money or win great prizes with Ellie Vayo Photography, simply by giving your business cards to your friends. Each time a senior presents your business card to us at the time of their sitting, you get credit for one referral.

If you refer:	You'll win:
Five Seniors (from any high school)	Portable CD player –or– seven CDs of your choice –or– $75.00 in cash
Ten Seniors (from any high school)	Two season passes to Cedar Point –or– $150.00 in cash
Fifteen Seniors (from any high school)	19-inch color television –or– $200.00 in cash
Twenty Seniors (from any high school)	Free stretch limo for the prom –or– $300.00 in cash

GRAND PRIZE!

If you refer twenty-five seniors from any high school, you will win an all-expenses-paid trip for two to Daytona Beach, FL. This trip will be taken the last week of June, after graduation. Or, if you prefer, you can receive a cash prize of $700.00 instead of the trip.

The contest starts the minute you receive your senior album and business cards and lasts until March 1 of the next year. Your senior album will be ready for you to pick up 10–15 days after your pictures are taken. Call now for your appointment!

Remember to bring us the brochures you receive from other studios—you'll receive $.50 for each one that you bring in!

Senior Representative Contract

This contract states that _____ will represent exclusively Ellie Vayo Photography for the 2001–2002 school year and participate in the benefits outlined in the student representative handbook.

It is understood that this is an exclusive relationship and that representation or advertisement of another studio will result in termination of the contract and all benefits associated with it. We also need the names, addresses and phone numbers of three students to be considered as student representatives for the 2002–2003 school year.

You will receive the following:
1. $15 for each student sent to us.
2. A black & white/color photo session (a $75 value).
3. You'll keep your senior yearbook and all of your previews (a $200 value).
4. $.50 for each mailer brought to us from other studios.
5. And any benefits of representing our studio!

Thank you,
Ellie Vayo Photography, Inc.

Representative Signature:_____
Date:_____

do, but we have found that assumption to be untrue! Believe it or not, many times it is the guys who bring in the most new clients.

It is always a good idea to have one of the parents present when your new representative is signing his/her contract, so they are involved in the process. Keep in mind, sometimes the parents' word of mouth is just as good as the seniors'! The most important thing when implementing a senior representative program is to make sure that it works for the *senior* as well as the *studio*!

EXCLUSIVITY

Our student representative contract requires an exclusive relationship between the representative and our studio.

Rewards. We found that our hard-working representatives needed some compensation for going to bat for our studio, so we put together a highly motivational rewards schedule—and it really did the trick. If a senior recruits:

• **Five senior portrait clients,** they win a CD player, seven CDs, or $75.00

Because of the increasing access your customers have to computers, a web site is an essential tool in today's business world.

• **Ten senior portrait clients,** they win two season passes to Cedar Point or $150.00
• **Fifteen senior portrait clients,** they win a 19" color TV or $200.00
• **Twenty senior portrait clients,** they win a stretch limo for the prom or $300.00

Recently, we had two super-star reps who referred twenty-five clients each. We offered each of them a choice of an all-expenses-paid trip to Daytona Beach (which they couldn't use until they were 18 and had parental permission) or $700 cash. One took the trip for spring break in her senior year, the other opted for the cash.

While $700.00 may seem like a big payout to make, just think about how much money those twenty-five new clients will spend at your studio!

▶ WEB SITES

Every day, more and more people are purchasing personal computers and getting connected to the Internet—to get information, to comparison shop and more. It has become unusual to find anyone who doesn't have access to the Internet and, therefore, the ability to send e-mail and visit their favorite web sites every day. Because of this, a web site is an essential tool in today's business world. Without one,

you are cutting yourself off from a large group of your potential customers.

Your web site should feature good, clean images. Your site should be energetic—including music and animation, if possible. Most importantly, the site should be easy for clients to browse. We have recently started allowing seniors to book appointments on-line—this is a great opportunity for studios to fill their appointment books. Seniors can simply log on at any time of the day, choose a session, pay by credit card and select from three possible session dates—all in a matter of minutes. Each day, my employees check the web site and take care of the appointments. Having a web site is a time- and cost-efficient way to advertise and book appointments.

Once your web site is up and running, it is important to update it often and include any specials the studio is running.

▶ CDs

A new and innovative form of computer advertising is the use of CDs. You can create these CDs using a CD burner. Featuring a commercial for your studio (and whatever else you like)

Featuring a commercial for your studio (and whatever else you like), **CD** business cards are a great way to catch the attention of the computer-literate high school senior!

they can then be handed out like business cards and seniors can watch them on their PCs. This is a great way to catch the attention of the computer-literate high school senior! To keep costs down, we burn 100 CDs at a time. As a sticker attached to the CD cover explains, seniors receive a discount on their sessions when they return the CD to the studio. We can then redistribute the CD to future clients. This CD is really popular with seniors because they can simply pop it into their CD drives and listen to the music, hear the message, and see their friends right on their computers.

▶ T-SHIRTS

At Ellie Vayo Photography, we've found another way to get the word out . . . with T-shirts. We had 100–200 T-shirts printed with "Class of 2003" and a snappy Ellie Vayo Photography slogan on the back. These are giveaways—we hand them out when students come in to view our slide show. The chance that kids will actually wear these shirts is really quite good—and with your logo printed on them, these kids become your walking billboards!

POSTCARDS

We used to send these out as first or second mailers, but we thought we'd go one better—with ten-page mailers. After all, the competition was already saturating the market with their postcards and, when you're trying to stay on top, you need to exceed client expectations. We still use postcards—only we now use them as follow-up mailers. When designing postcards, follow the advice given on pages 20–31 for mailers—use eye-catching photos and colors, make them look professional, and keep your message simple and direct. That's the best way to make sure potential clients actually read your card.

YELLOW PAGES

Using yellow pages ads has benefited our business, but has also been expensive. We ask everyone who calls for an appointment how they heard about our studio. About once a month, a client will answer that he/she found us in the yellow pages. While adding one client may not seem to justify the advertising cost, keep in mind that one client's session can pay for a lot of yellow page ads! Try to keep the ad as "clean" as possible (free from unnecessary design elements and visual clutter). However, pictures used in yellow page ads can be effective if they show up properly. Also, you should always advertise payment options such as Visa, MasterCard, Discover and American Express.

CONTESTS

Contests can be a big draw. Our studio is a member of a national organization called Senior Photographic International (SPI). They have a national convention every year—it's a great place to network with other professionals. Each year, SPI also gives away a Camero or a PT Cruiser. Every client that comes through our door is entered in this contest. As you can imagine this builds excitement. It also instills the steadfastness and security of the business in the student's mind. The association with SPI suggests that we are not a fly-by-night studio, but one with connections, and one that wants to give back to our clients.

IN CONCLUSION

Which form of advertising is the best? That depends on you, your market and a lot of other variables. The important thing to remember is that your goal is *not* to find the best medium for advertising, it is simply to *get your name out there*. The best way to do that is to build a business with exceptional customer service. If you do, you'll attract loyal customers who will in turn refer their friends.

Try to keep your yellow-pages ad as "clean" as possible (free from unnecessary design elements and visual clutter). Pictures can be effective if they show up properly.

Booking the Appointment

► THE CONSULTATION

When a confirmation is sent to a senior who has booked an appointment, it is always a good idea to encourage them to book a pre-session consultation at no extra charge. This consultation lets the senior know

what to expect from the session, and ask questions they or their parents might have. This session is also beneficial to you, because it gives you insight into what to expect from that particular senior! When you uncover his or her interests and personal styles, you can suggest props and clothing he or she should bring to the session. You can also evaluate any special needs the individual might have for creating a flattering portrait. Does he wear glasses? Is she overweight? Is he a blinker? Will she need makeup enhancement? All of this will contribute

to an enjoyable experience—for the both of you!

A senior doesn't have to have an appointment for a session before coming in for a consultation. Sometimes, seniors will drop in to see what you have to offer, so you should always have materials ready to show them. Of course, you *could* hand out the samples you have around the studio, but why not dazzle them with something that will make them eager to come back? A great tool is a senior slide show. Using Microsoft® Powerpoint®, you can easily put together a slide show, video or

Sometimes,

seniors

will drop in

to see what

you have

to offer . . .

computer presentation that shows your best senior work. Make sure that your presentation includes recent graduates (or brothers and sisters of upcoming seniors) and put it to music. A ten-minute slide show can book more appointments than hours of talk! Encourage the parents to come in for the consultation, as well—especially if they will not be at the session. Parents typically provide the financial backing, so you need to know what they expect, too. In the end, the seniors who come to the consultation *with* their parents generate the largest package sales!

▶ APPOINTMENT
CONFIRMATION MAILER

Many students work during the summer. Often, they're as busy as their parents are! Therefore, following up after making an appointment is very important. When clients forget their sessions and don't show up, time you could have spent making money is wasted. You need to take a couple of steps to make sure that your potential clients make it to that appointment.

You should *always* call the day before the session to confirm the appointment. This is a fairly obvious way to remind the customer—but other measures can also be taken. A confirmation mailer can be sent to the clients as soon as the session is booked. Or, send the client a magnet on which you have written the date and time of the appointment. The customer can put this on the refrigerator or in their locker at school. You can also send a coupon that doubles as a bookmark. The client can then present this coupon at their session and receive some extra poses or free wallets. Include a short brochure outlining what can be expected at the appointment and some tips on how to make it a great experience. A letter to the parent can be included in

After talking with a student during his pre-session appointment, you'll have a good idea of the kinds of props to suggest he should bring to the session.

any mailings that follow the scheduling of the appointment. In this letter, you should include information on session styles and prices—remember, nothing should be hidden from the client!

► TELEPHONE SKILLS

When dealing with customers, courtesy and professionalism are key. Your first phone contact with a potential customer is especially important because this may be the first contact he or she has with your studio.

Staff members who answer the phone should have excep-

A bookmark can be used to help your clients remember their session.

tional manners. They should also be informed about your studio's policies and operations so that they can comfortably answer any questions a client might ask. They should be helpful, friendly and relaxed— no matter how busy the studio might be at the time.

Hold. If a customer must be put on hold, they should never have to listen to dead air. Why not utilize that downtime to advertise a little more? After all, for the time that your client is on hold, you pretty much have a captive audience! Our studio recruited the services of JBC On Hold Marketing—a company that creates advertising messages that play when a client is on hold. We furnished a script that was recorded by an actress employed through the company. We receive monthly reminders from them about recording a new message. We put the cost into our marketing budget—this is a great time to get your message across. With this system, the customer can hear the latest information on your seasonal specials and get some additional information while they are waiting.

Keep in mind that hold time should always be minimal. No

one likes to be on hold. Your clients' time is as valuable as yours, and the longer they are kept waiting, the more impatient they will get. This is why it is important to have a system that allows multiple appointments to be booked simultaneously. That way, no one will be forced to wait for the appointment book and keep a client on hold. Our studio uses a networked computer system so all of our employees can book a session at any given time.

Question List. When booking appointments, the staff at Ellie Vayo Photography has some basic questions that they always ask the seniors. The answers to these questions help us analyze how our business is generated, and in the case of referrals/repeat clients, also lets our staff know that our great customer service is generating business. Other questions will help both the studio and the student gather impressions about what to expect during the session.

It is helpful to have a list of questions near every phone so employees don't forget important information.

• Have we photographed your relatives in the past?

This Information is for YOU, The Parent

Your son/daughter has reserved the studio at Ellie Vayo Photography for the creation of his/her senior portraits. In order that we may provide our best possible advice to you, this letter contains information that you, the parent, need to know. As you may know, Ellie Vayo Photography is not your "run of the mill" portrait studio. If this will be your first Ellie Vayo experience, you will probably find that our methods are a bit different, but the results and our reputation speak for themselves. Please take the time to read this information thoroughly and make sure that you and your senior are prepared for the creation process. There are many details in creating great portraits, and Ellie Vayo Photography will handle most of them. However, you are in control of some of the most basic and critical aspects.

Your investment in Ellie Vayo Photography portraiture today will be cherished for many, many years. We are always hearing from clients who say their Ellie Vayo portraits have brought them years of enjoyment—especially once their son or daughter is out on their own. We are sure you will find this to be true, and we ask your full participation and cooperation in making such an enjoyable heirloom.

Great portraits don't just happen. They are the result of efforts on both sides of the camera. Your studio reservation is a private creation session with our photographer and staff. We will be ready for you. Please be ready for us.

• Please instruct your senior to treat this reservation as they would any important appointment. It's a production in which they are the star. They should be ready and on time. When you reserve the studio at Ellie Vayo Photography, the studio is yours for the full period of time! If for any reason your senior will not be able to keep his/her appointment, please call the studio. We do offer this word of warning: Ellie Vayo Photography reservations are in high demand, and often rescheduling can't be done until October or November.

• We recommend that you do not schedule other activities on the day of your reservation. Rushing in for the session or "clock-watching" while you are in the studio creates stress and fatigue for you and your senior. This can be reflected in the final work and there is no magic wand to remove that!

• We have sent a packet of very detailed information directly to your senior. Your portraits will reflect the thought and effort you put into them, so please read that information completely. Elements of the portrait that are controlled by you include: sunburn, hairstyles, facial hair, nail polish, wardrobe selection, jewelry, makeup, etc.

• One last note: if you wish to match a pose or look we have done before, please bring the appropriate items for that pose, a copy of the print you wish to match, and let the photographer know your wishes before the creation process begins.

We hope this information is helpful to you. Everyone is very busy these days, and our aim is to give you all the tools necessary to make the process smooth and enjoyable—and the results incredible! The senior portrait is the quintessential portrait in American life. It will be enjoyed by generations to come, and we're proud to be the artists you've selected to create your portrait heirloom.

If you have any questions, please call us at (555)555-5555 or toll free at (800)555-5555.
Thank you for choosing Ellie Vayo Photography.

- How were you referred?
- Are there any future seniors in the family that would be interested in our representative program?
- Do you wear glasses? If so, try to get a pair without glass from your eye doctor. Alternately, we can remove the lenses from the frame.
- Do you have braces? If so, when are they coming off? If needed, we can digitally remove them (for an additional cost).
- Are you bringing a pet? Is it friendly? Does it have a history of biting? Is it current on its shots?

► E-MAIL FOLLOW-UPS

When you get students' e-mail addresses—or even better, the parents' addresses—you can e-mail them advertisements and keep them informed about future portrait specials. A successful strategy for getting repeat customers is to send out e-mail specials to those who have had pictures taken in your studio in the past. Some customers may not realize how long it has been since their last family picture, and will thank you for the reminder—especially if you offer a discount!

► CLIENT ENVELOPE

Upon arrival, every client signs in and we fill out an envelope with contact information, the type of session and a description of the client and their outfits. This helps us keep track of everyone that comes through our door. This envelope serves as a client file. We store any information pertaining to their session in this envelope—negatives, CD-ROMs, invoices, etc.—and file it away for safekeeping.

► SENIOR CLIENT INFORMATION FORM

When seniors come in on the day of the session, ask them to fill out a questionnaire that includes important contact information as well as family information (for example, do they have younger brothers or sisters who will be seniors?). An important part of that questionnaire is the e-mail information you'll gather (see previous section). This information will help you with future marketing efforts. A copy of our senior information form is shown on page 57.

► SESSION FEES

The session fee covers the "hidden costs"—like the photographer's time, film, yearbook glossies, etc. There is a lot of room for manipulation here. For instance, you can offer deep discounts during the slower months to draw clients. At Ellie Vayo Photography, the session fee must be paid in advance of the appointment for Saturday sessions. Otherwise, we collect the fee at the time of the sitting.

Invoice # 12499

Name:
Parent/Guardian:
Address:

Phone:
Email Address:
School:
Sitting Type:
Order Date:
Date Order Completed & Notified:

DEPOSITS
DATE AMOUNT
 $
 $
 $
 $
 $

Comments:

Date: Photog:
Description:

No. of Negatives:

Lab Order Sent To: Date Sent:
BUCKEYE:

HERF/JONES:
OTHER:
Siblings: Grad Year:

Misc:

Filling out a client envelope as each senior arrives for his or her portrait session helps us to keep track of every client that comes through our door.

Senior Client Information

Please take a moment to fill out the areas below:

YOUR PARENT/GUARDIAN LAST NAME FIRST NAME MIDDLE

❏ MR. ❏ MRS. ❏ MISS ❏ DR.
❏ MR. & MRS. ❏ DR. & MRS.

ADDRESS

CITY STATE ZIP CODE

HOME PHONE PARENT/GUARDIAN BUSINESS PHONE PARENT/GUARDIAN OCCUPATION

Do you have any pets? ❏ No ❏ Yes What kind? _____

Have you been a customer of our studio before? ❏ No ❏ Yes

From whom or how did you hear about our studio? _____

YOUR LAST NAME FIRST NAME MIDDLE

YOUR BIRTHDATE YOUR SCHOOL YOUR INTERESTS

If you have brothers or sisters, please complete the information below:

CHILD'S NAME	BIRTHDATE	SCHOOL	INTERESTS
CHILD'S NAME	BIRTHDATE	SCHOOL	INTERESTS
CHILD'S NAME	BIRTHDATE	SCHOOL	INTERESTS
CHILD'S NAME	BIRTHDATE	SCHOOL	INTERESTS

Preparing for Your Senior Portraits

What Do I Wear?

When choosing your outfits, the most important thing is that you like them. You'll want as much variety as possible. Most seniors choose some casual and some dressy outfits. *Avoid sleeveless and very short-sleeved shirts*, because upper arms can be very distracting—especially women's.

Guys—For more traditional portraits, a suit or sport coat with a tie is good. Medium to dark sweaters photograph well. For casual and outdoor photos, comfort is the rule—jeans, shirts, sweaters, shorts and sweatshirts.

Girls—Bring the colors and outfits you feel best in—dresses (even formals), sweaters and lace for the more traditional look, bright colors, skirts, jeans, and shorts for a more casual look. If you like an outfit, it's probably because you look good in it, so make sure you bring it! All white is great for a special high key effect. White is a strong color and is great when used **properly with a white background**. Blonde or light hair looks great with white clothing.

Shoes—Often shoes will show, so they should complement your clothing; changes may be necessary with different clothing styles. Many prefer barefoot poses.

What Else Can I Bring?

Here's where the fun really begins! Part of what makes Ellie Vayo Photography so much better is that we work hard to bring out the various facets of your personality. Make sure to bring your favorite hat, musical instrument, pet, sunglasses, hobby, letter jacket, wheels, uniform, sports equipment, class ring or anything else you feel would show off the real you. Don't forget seasonal activities too: swimsuit, boom box, fishing or skiing gear. No idea is too crazy, and since we will only try a few poses with it you have nothing to lose—so go for it!

Can I Bring Someone With Me?

Absolutely! Some people find it more comfortable to bring Mom or Dad, a friend, brother or sister along to help ease the "camera room jitters." You are always welcome to bring someone with you.

Do You Have Drapes?

We have several sizes, styles, and colors available for use. These add a nice elegant look when used with soft focus.

What About a Suntan?

Too much sun darkens your skin unnaturally, dries out your hair, makes skin appear shiny and greasy and shows bags under your eyes. Strap marks will show as white marks on draped poses or bare shoulder poses. These cannot be retouched. Keep your tan even. Don't overdo the sun for a portrait—it looks great, but only in moderation. Sunburn is a real problem. Reschedule your appointment if burned.

What About My Hair, Makeup, or Glasses?

Hair—Try to have your hair cut and/or permed at least one week before your session, to give it a chance to "fill in" a little. Don't try a radically different haircut or style—chances are you won't feel it expresses the "real you." Wait until you have seen your previews before trying something new.

Makeup (Guys Too)—Here's a quick hint that will greatly enhance your portraits: just before your session, stand two feet in front of a mirror. Dab a small amount of cover-up makeup on any noticeable blemishes. That's it—if they're gone in the mirror, they'll be gone in your photographs.

Glasses—If you wear glasses most of the time, you'll want to wear them in your portrait. To eliminate glare and reflections, call your optician and arrange to borrow a pair of empty frames like yours, or have the lenses removed from your own glasses. Most opticians will gladly do this for free (make sure you give them plenty of notice). This totally eliminates glare and distortion and is the most important way to improve your portraits if you wear glasses. It doesn't take much effort, and it sure makes your pictures look better!

What If It Rains?

If you planned to have some of your poses made outdoors but it looks like rain, *no problem*. Posing areas in our outdoor garden are sheltered from the weather, so you won't get wet, even in the rain! Also, summer and autumn showers come and go quickly—it might be raining where you are, but sunny here. If the weather seems to pose a problem, we'll call you. If you don't hear from us just before your session, assume that your appointment is still on! It's easier for us to reschedule the outdoor portion of your session instead of the entire session.

How Much Money Should I Bring?

The only thing you need to bring to your session is your session fee of $_____ (unless you have already prepaid it). This covers the cost of the photographer, plus the expenses for your portrait session. It does not include any photographs, but it *does* include the best senior photography you can get anywhere! (Remember to bring any applicable coupons.)

When Will My Previews Be Ready?

Normal delivery time is 7–10 working days. When you pick up your previews, a minimum deposit of $200.00 is required. This ensures safe return of the previews, and will be applied to your order.

Remember—
The previews cannot leave the studio without your deposit. No exceptions, please!

Black & White Portraits

We are proud to offer dramatic black & white portraits for added variety. Please bring any special outfit that you would like to be photographed in. We suggest any dark outfit with patterns or designs. Avoid all white. Several outfits will be available at the studio for you to choose from, as well. Jean jackets make an excellent choice for clothing.

What Can I Expect at My Photo Session?

First, expect to have a great time, because you will! It's okay to be a little nervous at first, but you'll soon relax with our easygoing manner and super creative photography!

Plan on arriving fifteen minutes before your scheduled time, dressed in one of your outfits. This will also allow you time to freshen up. We will spend a few minutes with you going over your clothing choices. Remember, we want you to have fun—and being late will only result in your feeling rushed and having less time spent on your photography.

Bring your favorite music. We have a CD and tape player in the camera room, and we like all kinds of music. So bring a tape or CD, or pick from our CD collection.

Be sure to wear one of your indoor outfits to the session to save time. Pick the one that you consider most traditional. It's okay to bring more than the recommended number of outfits if you're not sure what would look best—we will help you pick the most photogenic ones.

Please remember your session fee (cash, checks, MasterCard and Visa are accepted).

If you're unsure of something or have any questions before or during your session, *please ask!* We want you to feel comfortable so you can get the *best portraits of your lifetime!*

Stop in anytime!

Checklist to Bring:

uniform (cheer, band)	instrument
pet (additional $10)	sun outfit
shorts	dress glasses
sunglasses	(borrow empty frames)
swimsuit	brush
stuffed animals	makeup
hobby	belt
session fee	shoes
"me" stuff	favorite poster
letter jacket	"wheels"
hat	class ring

Day of the Appointment

▶ STUDIO ATMOSPHERE

Many people ask, what is the formula for a successful photography studio? The answer is a creative pre-sales program, excellent customer service and a warm and pleasant atmosphere. The latter is more important than most people think it is!

Environment. The first step to making your clients feel comfortable and welcome is to provide an atmosphere in which they can relax and feel at home. The students should be treated as guests in your home, because that is exactly what they are. My studio captures the essence of comfort with its Victorian décor and a fireplace that warms the waiting room in the winter. Beautiful portraits hang above the mantle and couch, just as they would in someone's home. This atmosphere does more than make the customer feel completely at

Creating a warm and pleasant atmosphere at your studio is more important than most people think it is.

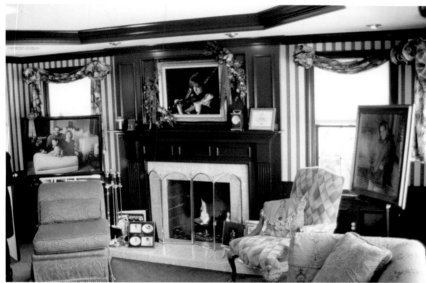

Your studio should have an inviting appearance. When clients get inside, seeing finished portraits on your walls will help them envision how portraits will look in their home.

DETAILS

The little touches mean a lot. We like to use fragrance, candles and music to help put our clients at ease. Our goal is to create an experience that they'll remember for the rest of their lives, and to achieve their lifelong loyalty to our studio!

first session, you will be photographing not only younger brothers and sisters, but also their weddings, families and children. While initial appearances make for a great impression, they mean nothing unless the special treatment is continued throughout the session.

When clients arrive at my studio for their session, an associate takes the clothing they have brought for the shoot and neatly hangs it up in their personalized changing room (which has their name right on the door). Each room is stocked with items they may need to look their best (hair spray, shaving cream, disposable razors, lotion, etc.). The idea is to make the client feel like a star during the session.

In many cases, the senior has brought friends and family to

ease before and during their session—it helps them imagine what their finished portraits will look like hanging in their home.

Many photographers seem to forget that we live in a society that revolves around *service*. If we do not cater to the clients' needs, they will move on to someone who does. Every student and parent that walks through your door should be treated as though they are already a lifelong customer. If you win them over with their

Small details, like a personalized sign on the dressing door and an available supply of refreshments go a long way toward creating an enjoyable session.

join in the fun, and it is important not to leave these guests out. Small acts of politeness go a long way. For example, we like to keep a small refrigerator stocked with soft drinks and bottled water, and offer them to our clients and guests. Keep in mind, most senior portraits are taken in the hot summer months, so your clients will be especially appreciative of this gesture. Remember that any guests of the senior are your new friends—and potentially your new clients!

► PSYCHOLOGY OF THE TEENAGE GIRL

The summer before the senior year can be a very important one for teenagers. To most, it marks the end of an era—and

they may be having a difficult time dealing with that. That is why their senior portrait photo session means so much to many of them (and to their parents, too!). Unfortunately, there are plenty of little things that can send this important session on a path to destruction; the key to gliding through it successfully is to understand how to get past those little things.

Setting the Mood. It is up to the photographer and the studio staff to create a calm environment for the client. This can be difficult when you have a seventeen-year-old girl who is running late and having a bad hair day! Before she even walks through the door, she is feeling rushed and nervous. You must

Facing Page: Creating a calm environment will help put clients at ease, and result in more natural poses and expressions.

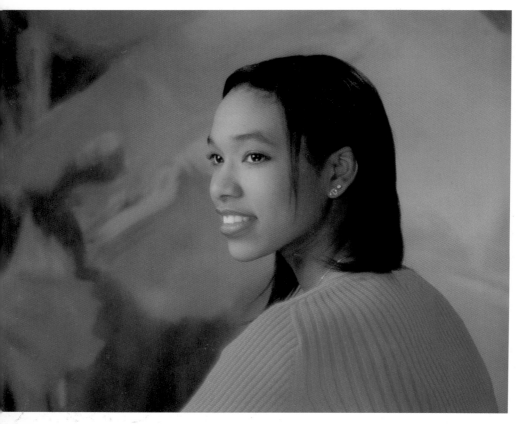

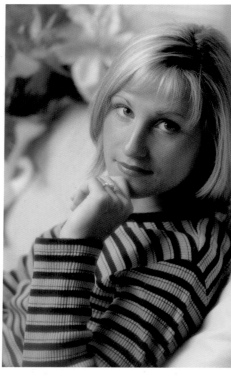

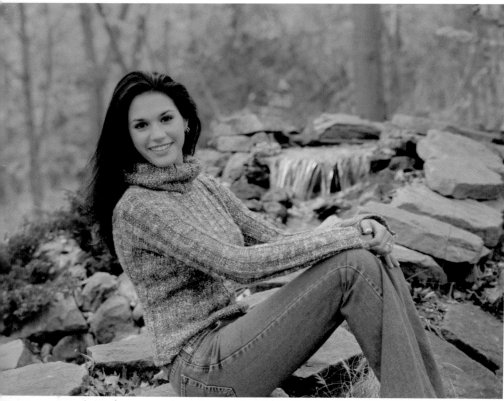

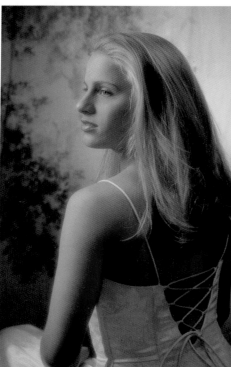

Above, left, and facing page: The inter-personal skills you bring to each session are critical to your ability to create suc-cessful images with each young woman.

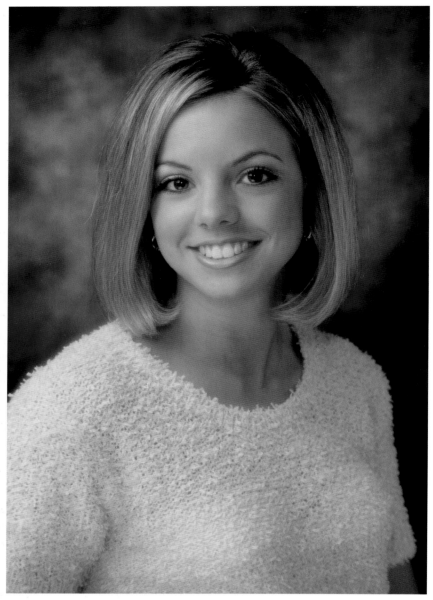

Make sure you have someone on your staff who really knows what he or she is doing when it comes to makeup, and who can help your client look her very best.

camera room—unless Mom or a friend is there to help. Rely on your artistic eye and your assistant's attention to take care of stray hairs and kinks. No teenage girl is ever completely happy with the way she looks—and if you let her check the mirror before every shot, you'll be there all day! Your job is to make sure that everything looks good in the camera. When you're confident that it does, your client will usually agree.

Makeup. The senior girl may want her makeup done by your on-staff makeup artist (always a good idea to have!). Even if your client has made other plans, you will want to have someone present who can enhance her makeup for the camera or do touch-ups. Because most women aren't used to the increased amount of makeup that is ideal for the camera, your client may be a little skeptical. This is where she will need to trust your expertise in order to make her look great. Do not let her down; make sure you have someone on staff who really knows what he or she is doing when it comes to makeup. Make your client gorgeous at all costs!

remember that this is an extremely emotional time for your senior client, whether she realizes it or not. While you may get the occasional child-like temper tantrum, you must treat this young woman as an adult—difficult as it may be. Many teenage girls love to have

their pictures taken. Some will show up with ten outfits they want to wear, and you'll have to narrow them down to four.

Hair. It may sound silly, but hair can make or break the photo session. Because of this, it is always a good idea to have an assistant with you in the

Most teenage guys couldn't care less about getting their senior portraits taken. In many cases, it's actually Mom who has made the appointment—and he has been forced to come. Last summer, only about 30 percent of our senior clients were guys, but this number is improving every year.

So, what do you do when you get a guy who just isn't interested in being at his portrait session? First, remember that successful sessions with guys can only happen if your subject is willing to work with you. So, now your question is not how to get him *interested* in the session, but how to get him to be *cooperative*. This is a much easier task.

One on One. First, if Mom has come with him, he will probably be much more comfortable without her in the room. Offer her a beverage and explain to her politely that you'd like to try it one on one. You will probably find that once you are alone with him, you can joke around a little more and he may open up.

Expressions. Also, you have to realize that getting a dozen different facial expressions from a guy who doesn't really care about the portraits in the first place just isn't realistic. Work with his mood. If you can get some good smiles then go for it, but many times that tough-guy look will actually suit him better anyway.

Guys will often feel more relaxed and comfortable if you ask their moms to leave the room (or area) for a few minutes so you can work alone with them.

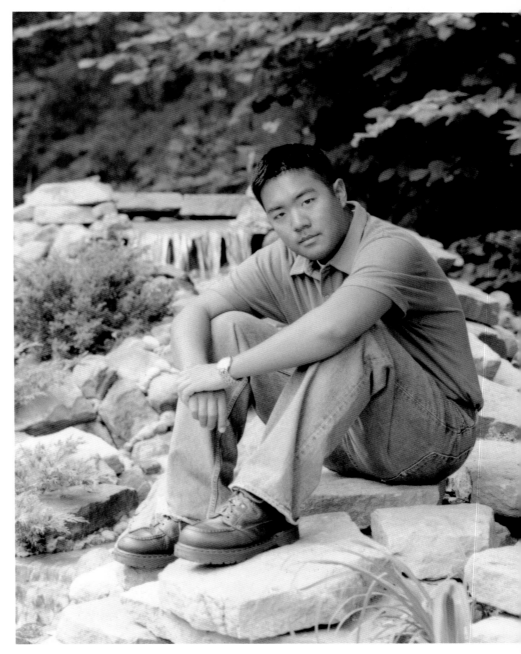

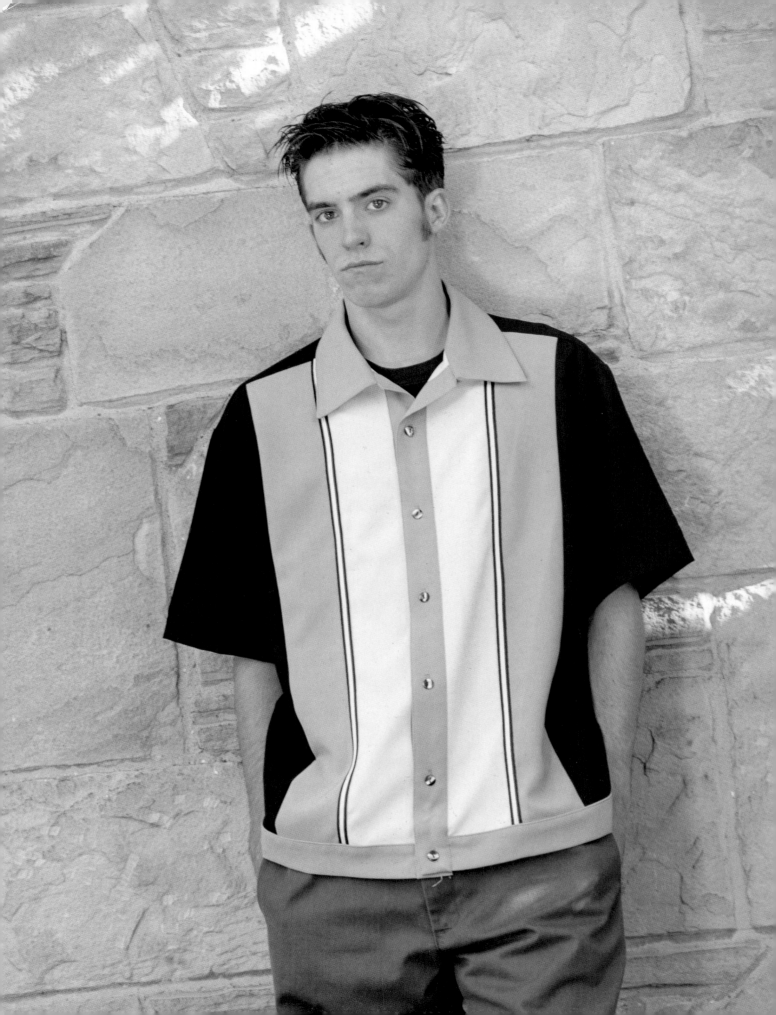

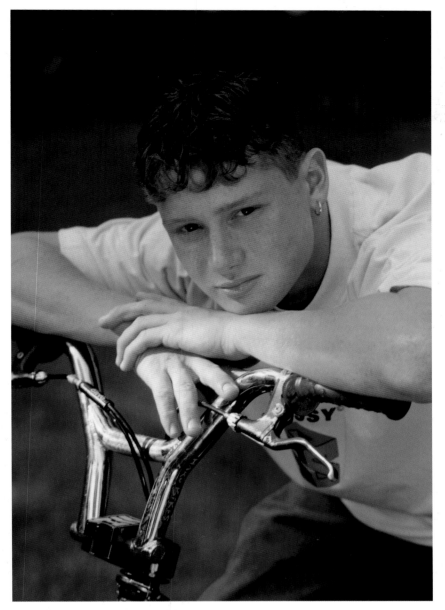

Facing page, left, and above: Great portraits of guys start by establishing their cooperation—after all, moms have to force many guys to get their portrait done!

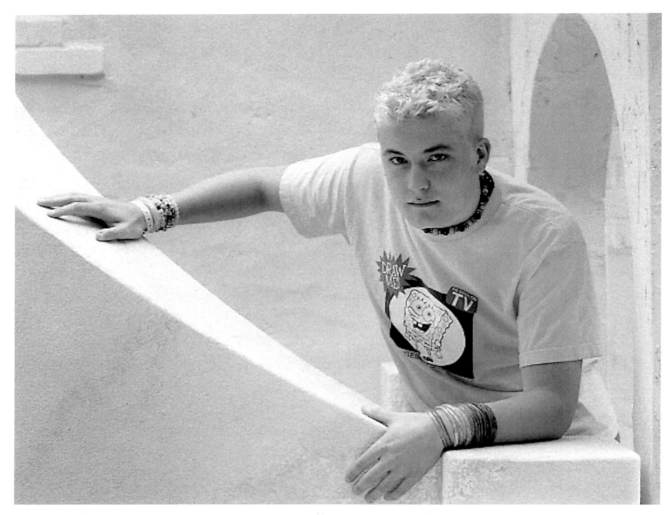

Makeup. Don't be afraid to call in your makeup artist for the guys! Sometimes his bad mood doesn't stem from his distaste for photography at all. It may come from feeling self-conscious about that pimple on his forehead. Do not hesitate to cover up any blemishes. Be sensitive, but do not be shy. He may feel a little strange about wearing makeup, but after you explain that it is very common and necessary for most guys, he will probably lighten up.

Applying makeup has its benefits for the photographer, too. If a client has acne, applying makeup for the shoot will shorten the amount of digital or traditional retouching that may be necessary. The same is true for birthmarks, scars, etc. Your makeup artist can really work magic and help to boost your client's confidence.

We look at every client as a new challenge. This comes from a true love of the trade. Whether it is a crying child or

If you can get some good smiles then go for it, but many times that tough-guy look will actually suit him better anyway.

a stubborn senior, it is the experience and skill of the photographer that makes a great portrait.

► SELLING TO MOM

The studio staff should always ask if the student's parent would like to sit in on the session and watch the big event unfold. This is important for you as the photographer, because the final package is usually the parents' decision.

At Ellie Vayo Photography, the parent who wishes to watch is usually guided to a big antique chair that we call the "Queen Mom's chair" or the "King Dad's chair." Not only is this a comfortable place for the parent to see their senior pose for his or her pictures, but the chair is also situated such that the parent is surrounded by packages displayed on the walls of the camera room. This way, from the time they walk into the camera room they are thinking about what would look good on their walls at home.

From the very beginning, you should help the parents to see how their senior's portraits will decorate their home beautifully. Preselling to the parent— explaining everything the stu-

The "Queen Mom's chair" or "King Dad's chair" is also situated such that the parent is surrounded by packages displayed on the walls of the camera room.

Ample samples will help you presell to the parents, so they can begin to consider their needs before they even see the images.

You should have on hand a wide selection of sample frame moldings that the parents can take with them to match the décor of their home.

dio offers before they see the previews—will help him or her consider their needs before they even see the images. You should have on hand a wide selection of sample frame moldings that the parents can take with them to match the décor of their home, if they wish to do so. You should also be prepared to answer any decorating questions they have and offer suggestions. When parents have ample information and ideas, their orders will increase tremendously.

Remember that your presale efforts will be very important to the parents. This is an emotional time for them. After all, these photographs may mark the final steps that their son or daughter will be taking before going off to college or leaving home. You can't put a price on a memory that will be cherished forever.

▶ THE CAMERA ROOM

The informed client is a comfortable client. At Ellie Vayo Photography, we give the client—and Mom or Dad—a brief tour of the equipment and sets that will be used to create their photographs. After all, many clients are completely unfamiliar with photography equipment. Explaining the roles of the lights, reflectors, etc. will take some of the mystery out of the session, and will help the client feel involved in the artistic process.

▶ FLATTERING YOUR UNIQUE SUBJECT

Many photographers fail to photograph their subjects in appropriate ways. They may end up with decent prints and sometimes even good ones— but not consistently excellent images. Your perfect subject may be 5'10" with gorgeous hair, a beautiful smile and a body that could stop traffic—it would take talent to *not* get a perfect shot of her. But you live in the real world, where every woman isn't Barbie, and every man certainly isn't Ken.

While you surely commit yourself to creating pictures that your clients will love, it is hard to do that when the clients themselves sometimes don't even like the way they look. Photographers aren't magicians, but there are a few tricks of the trade that every photographer should know. Those

MOM

Approach Mom when the student is changing his or her clothes. Ask her whether she has any other children that have been photographed by your studio, and whether or not she is looking to match the portraits so they can be displayed together (you can pull up the proofs and try to create a compatible photograph). This is also a great time to find out when the last family portrait was made and discuss family packages.

The same subject is featured in both of these images. The picture on the right features a beautiful, and much more flattering angle for this subject.

tricks include careful techniques for posing, lighting and evoking great expressions. Like snowflakes, no two subjects are alike. Every subject has different features you want to emphasize, and some you'll want to *de-emphasize*.

Full-Figure Subjects. If you are photographing a heavy subject, a good rule of thumb is that the weight should be kept to the back of the image. Always chisel out the good features. For instance, if a woman has large hips and heavy arms, hide the arms behind a prop or draping and take the portrait from the waist up.

Eyeglasses. Many times a client that comes in wearing glasses doesn't realize how great he or she looks without them. The client may insist on wearing the glasses for the pictures, but that doesn't mean you are stuck with retouching glare. When the client books

CAMERA ANGLE

The angle from which you shoot is very important. Find the one that suits your client best. Study fine portraiture by going to your local art museum. The old masters really knew how to use angles to their advantage.

the session, you or a staff member should suggest that he or she have the lenses taken out on the day of the session. Most optometrist's offices will do this at no charge, and they can be easily replaced after the session. This is the only foolproof way to avoid glass glare. To cut down on glare when the lenses are in, use camera lights at high angles and do not use reflectors. If all else fails, your studio should become familiar with digital retouching. This is an excellent and efficient way to retouch any remaining glare (and a lot of other problems).

Other Problems and Solutions. Here are a few more tips that will help you to correct some of problems commonly encountered when photographing seniors.

Problem: The subject has one eye that is larger than the other.

Left: The only foolproof way to avoid glare on glasses is to have an optometrist remove the lenses from the frames before the session. Right: If the subject has one eye that is larger than the other, posing the subject with his smallest eye closest to the lens will help create a more balanced appearance.

Solution: If you pose the subject so that the smallest eye is closest to the lens, the back eye will be balanced (see photo on facing page, right).

Problem: The subject is very tall.

Solution: Get on his level. Use a stepladder or lower him to your level, perhaps by seating him.

Problem: She has a double chin.

Solution: Do not use reflectors under the eyes. This will only enhance the chin area. Instead, shoot at a higher angle so that the she is looking slightly upward.

Problem: Large upper arms and a sleeveless shirt.

Solution: Use a long-sleeve sweater from your studio wardrobe to hide arms or angle the camera to shoot at a higher level (see photos at top of page 76).

Problem: The subject is heavy but wants to show a lot of body.

Eliminating reflectors under the eyes and shooting from a high angle with the subject looking slightly upward will help to conceal problems in the chin area.

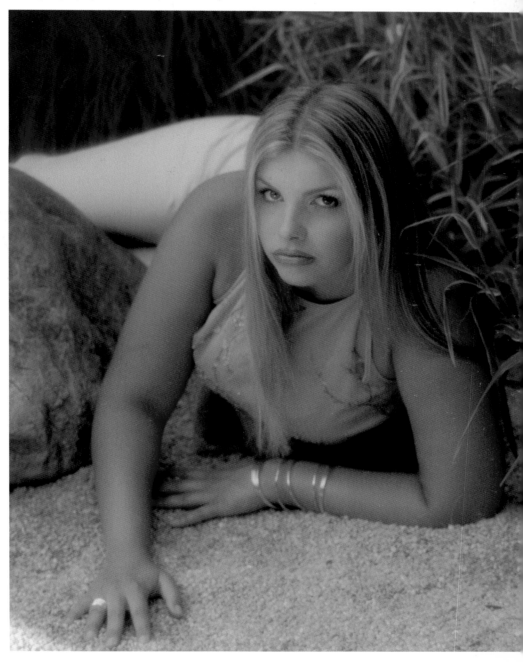

If the client brings sleeveless or short-sleeved shirts, long-sleeved sweaters from your studio wardrobe can be used to hide arms.

Solution: Angle her as much as possible. Plants in outdoor areas make good cover.

Problem: Your senior has tattoos or body piercings that his parents would like hidden.

Solution: Photograph him with the tattoos, body piercing and any other little additions that Mom and Dad don't like. These things can easily be digitally removed when they pick their favorite poses. It may cost extra, but it is well worth it to prevent tension between parents and senior (not to mention the extra shots you would be taking to get poses with and without them!). Examples are shown on the facing page.

Problem: The client has a shaved head, with small "bald" spots that show through.

Solution: Angle the hairlight down a bit toward the client's back to de-emphasize the bald patches.

▶ CLOTHING

Many seniors will have questions about clothing when they come in for a consultation, but

there are also those seniors who have it in their heads that a plaid skirt and strappy top will look just great on camera. Bad clothing selection can be a nightmare for a photographer. So how do you get past the clothes and still create great pictures for the senior?

Clothing Consultation. As discussed in chapter 3, clothing selection is a vital component of good portraits. Giving your clients the information they need to make wise decisions about what they will wear at their sessions is really important. If the senior schedules a pre-session consultation, be sure to address the issue then. You should also send a mailer that outlines clothing suggestions to the senior after you book their appointment.

It may seem obvious, but when it comes to selecting clothing, seniors want to wear something they like, and feel comfortable in. While most clothing options will work—from sweaters and jeans, to uniforms and letter jackets, to shorts and T-shirts—sleeveless shirts or tops with very short sleeves are sometimes very unflattering in portraits, and should be avoided.

As mentioned earlier, each senior should bring a variety of outfits—about four or five selections ranging from casual to dressy. Be careful about asking them for more. We find that the more outfits they bring, the longer we'll be in the session and the more confused they will be! I always look at the clothing each senior brings

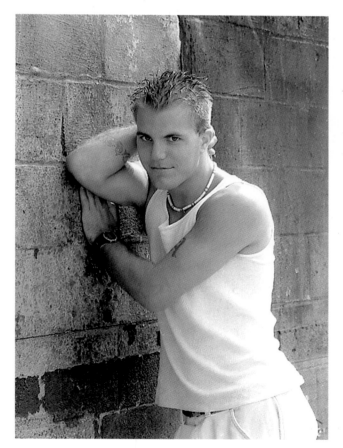 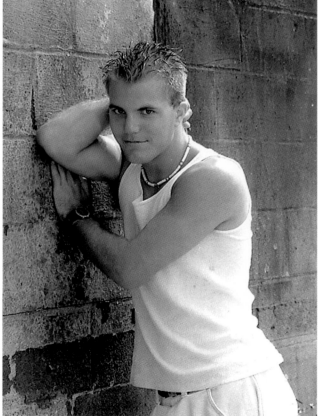

For seniors with body piercings or tattoos that Mom and Dad don't like, digital retouching can be employed to remove the adornments after they pick their favorite poses.

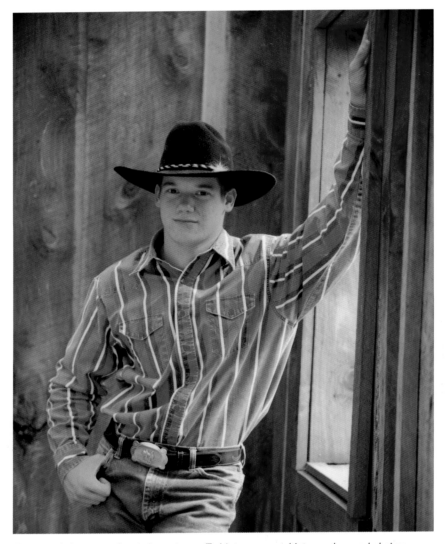
For casual shots, comfort is key—jeans, T-shirts or sweatshirts can be good choices.

more formal shots of the girls, dresses—and even sweaters—work well. Bright colors, jeans and shorts work well in casual shots. White clothing is a good choice (except for heavier clients), and is great when used with a white background to create a flattering high-key portrait. Light-colored hair looks especially great with white clothing.

Solid clothing—items without patterns, stripes or logos—work best. Students may not understand how distracting prints can be in their images. As the photographer and artist, it is in your best interest to steer clients away from loud clothing—whether it's by recommending another outfit the client brought along or suggesting something from your studio wardrobe.

Studio Wardrobe. What happens if, despite all of your efforts, a student still shows up with bad clothing choices? You'll find that purchasing a studio wardrobe is an excellent investment (and can save the day). Keep a closet of basics that you can pull out to add to any session. Include items like ties in solid colors, sports jackets, belts, sweaters, denim jack-

along and give them advice between outfit changes. Usually they trust my advice, and that trust is key. They have to have faith that you, as an artist, really want to help them to look their best.

For more traditional photos of the guys, a suit or sports jacket works well. Medium-toned to dark sweaters also photograph very well. For casu-

al shots, comfort is key—jeans, T-shirts, sweatshirts or shorts can be good choices. Because shoes often show in portraits, students need to ensure that the shoes they bring along will complement all of their clothing choices. However, many students prefer bare feet.

The clothes that students feel best in are usually the ones that look best on them. For

ets, leather jackets and hats. Any of these items can be altered to fit the senior by simply using a safety pin.

You don't have to spend a fortune building your studio wardrobe. The items are basic; they don't have to be designer-label garments! Look in discount clothing stores or thrift shops. You will probably find most of what you need for next to nothing.

Getting your senior to wear any of these items may be trying, but suggesting that he or she take just a couple extra shots (in addition to the ones already included in their session) may sway them in your direction. In the end, you may find at least one of these shots in their ordered package!

We also stock "drapes" in several sizes, styles and colors. These add an elegant look when used with soft focus. As mentioned earlier, they can also help to conceal heavy arms.

► JEWELRY

At Ellie Vayo Photography, we carry our own jewelry line. We have always kept a selection of jewelry on hand for our glamour images, and have just carried that concept into the senior market. The jewelry is displayed in a special showcase. We tend to do a lot with silver—and it's really hot right now. In fact, about half of our clients use the jewelry. Of course, having pre-selected, pre-approved jewelry on hand allows the photographer to recommend pieces that will add a little bit of interest to the image, but won't be overwhelming.

► ACCESSORIES

Your client's personal belongings can really add personality to their images. Encourage your clients to bring their favorite "props"—the "me stuff" that helps to define who they are. A musical instrument and a band uniform will tell a story about the client, as will a car, stuffed animals and even a family pet. (We charge extra to include pets in the session. Be

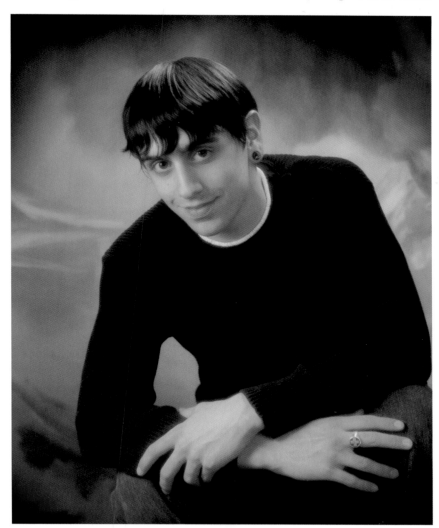

Solid clothing—items without patterns, stripes or logos—work best.

sure that the pet has its shots and is well-behaved before the client shows up to the shoot.)

▶ RAIN DATES

So, what if it rains? At Ellie Vayo Photography, our outdoor posing areas are all sheltered from the effects of bad weather. If weather is particularly problematic, we call the client before the shoot to reschedule the outdoor portion of the setting, but reassure them that they should still come to the studio for the indoor shoot. After all, it's easier to reschedule a portion of the session than to reschedule the whole thing! If your outdoor areas are unsuitable for use in rainy, windy and snowy days, be sure to let the client know that you'll need to reschedule that portion of the shoot before he or she arrives.

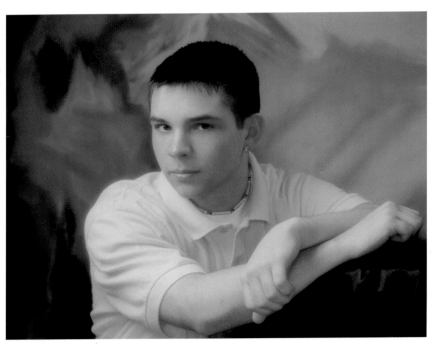

When the weather is a problem, we ask that clients keep their appointment so we can do their studio shots. We then reschedule the outdoor part of the session.

Indoor Equipment and Film

▶ STUDIO LIGHTING

Our studio is proof-positive that you don't have to have an enormous camera room to get a variety of different looks. Our 16' x 25' camera room hosts more than 600 noncontract seniors each season. It is amazing how well you can make a small area work with good lighting. The following lighting units are found in my camera room:

Main light—26" x 30" Studio Master II Photogenic with grid covers

Fill light—A 600-watt Photogenic power light, placed behind the camera

Hair light—Larson Soff Strip 9" x 24"

Reflector for side fill—36" x 38" silver reflector on stand

Eye control—17" x 25" silver reflector (lights dark circles beautifully!)

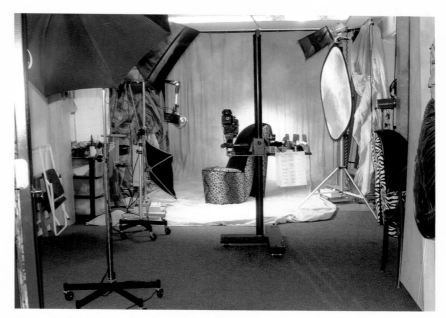

Our studio is proof-positive that you don't have to have an enormous camera room to get a variety of different looks.

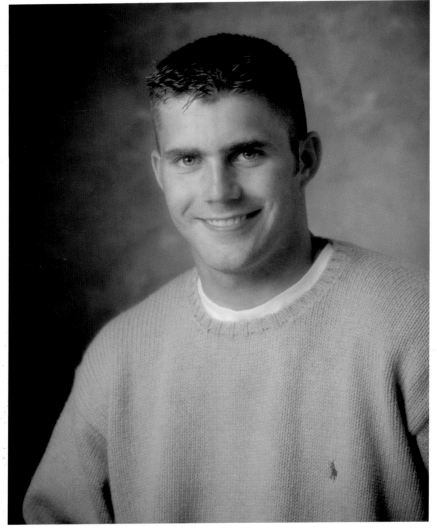

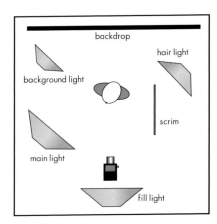

I use a standard four-light setup: a main light, a hairlight, a fill light and a background light. It is best to keep lights away from each other, and to avoid bleedouts. This is a mistake many photographers make in photography today—they wash everything out.

The Main Light. The main light, also called the key light, is the dominant light source. This light should chisel out the "mask" of the face, and should be a little bit hotter than the other lights. My main light is a softbox with louvers in the front. Softboxes are a good choice for use as a main light as they are very forgiving. After metering, I make sure that my main light is 1–1½ stops hotter than my other lights.

There are several different ways the main light can be used. It all depends on what you want to light and your subject matter. If your subject is thin and has a great face, you'll want to shoot it from all angles—straight on without hands for a good yearbook pose, another head and shoulder with arms folded (without hands showing), and one that's a little hotter on the face, with the hands showing. Our 26" x 30" main light with ribbon grid covers act as a great softening on the face.

Fill Light. The fill light should be placed so that is picks up shadow areas and fills them in with gentle light. The fill light, generally placed behind the camera, should produce just enough light to lighten up the shadows—it should not overpower the main light or the reflectors. You want the colors to remain rich and to "pop."

Accent Lights. The hair light (we meter it at F5.6 to F8) provides definition between the subject and the backdrop, preventing them from seeming to blend together. In the photo to the right, notice how beautifully the subject is separated from the backdrop, without the effect being too overpowering. I like to use umbrellas and silver reflectors for this purpose.

The Background Light. There is no rule on background lighting. Sometimes I use more than one light on the background. For instance, if I am draping muslin from one pole to another, I might fire a background light into the back por-

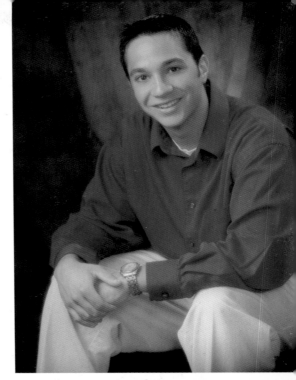

The hair light provides definition between the subject and the background, preventing them from seeming to blend together.

tion of the muslin, then use another light to illuminate the front-most portion.

The main point to keep in mind is that you want your subject to remain the center of interest in the image. If you stay focused on that goal, you can be really creative in lighting the background. For exam- ple, I've found that placing var- ious colored gels on the back- ground light can really add interest to the image.

If your subject is wearing a black leather jacket, you can aim a background light on the background, and direct another just over his shoulder to light the leather. It is difficult to show detail in black. For the best effect, meter the black leather jacket and adjust the background light until the light that falls on it reads one stop less than the main light.

Again, lights should be used in a way that produces the best effect in the image. Don't fall into the habit of using only one light in one way—simply adding gels or additional lights can vastly improve your image.

LIGHTING TIPS

- **Reflectors**—I use two silver reflectors that help to sculpt the face: one as a fill light, and one directed right under the eyes—it fills out the undereye area for clients with deep-set eyes or dark circles. Silver reflectors are *not* used under the chins when photographing a client with a heavy face—it is more flattering to chisel out the cheek- bones with overweight subjects. It is also not a good idea to aim a softbox under the face if the client is wearing glasses, as reflections can result.

- **Umbrellas**—Umbrellas produce a softer light than what is required for direct or Rembrandt lighting (see page 87). With this type of modifier, light from the strobe is fired into an umbrella and bounced back onto the subject. I use umbrellas that are white on the inside and black outside. (Umbrellas are especially great when shooting on location because they are lightweight and easy to carry.)

- **Snoots**—A snoot is a metal adapter with a long "nose" that attach- es to a light. If a client has dramatic eyes, I like to use a second main light with a snoot attached, which will help direct light right toward the eye area.

- **Remote Triggering**—Using a remote triggering device like a Pocket Wizard® to fire your lights will help you to keep your camera room floor free from tangled electrical cords!

▶ LIGHTING STYLES

Broad Lighting. In lighting, the face is generally divided into two sections. Picture a man facing you, but looking 45° to the left or right. The side of his face where you see his ear is called the broad side (because you see more of it), the side where his ear is turned out of view is the short side (because you see less of it).

Broad lighting describes a pattern of light on the face where the broad side of the face is illuminated by the main light and is, therefore, rendered as lighter than the short side. With broad lighting, the subject is seated on a stool, facing the camera with his face turned in toward the main light. The opposite side of the face is in

Above: In broad lighting, the face is angled slightly away from the camera and the wider side of the face is illuminated. Right: In short lighting, the face is angled slightly away from the camera and the narrower side of the face is illuminated.

shadow. Broad lighting chisels out the mask of the face.

Short Lighting. Short lighting describes a pattern of light on the face where the short side of the face is illuminated by the main light and is, therefore, lighter than the broad side. This is a favored type of lighting. For this style, the face is turned away from the main light, but is still looking back into the camera. The side of the face turned away from the camera is fully lit, the side closest to the camera is in shadow.

Profile Lighting. Profiles must be handled delicately. The main light should be positioned so that a triangle of light appears on the left cheek. For instance, if the main light is on the left side, the subject should be turned into that main light for a side profile. The hair on the right side should be tucked behind the right ear and kept out of view of the camera. The rest of the hair will be fine placed in any way that creates an attractive view. It is very important the the nose stay within the cheek line, creating a triangle between the forehead and the upper lip. This is a great effect if the guy has an

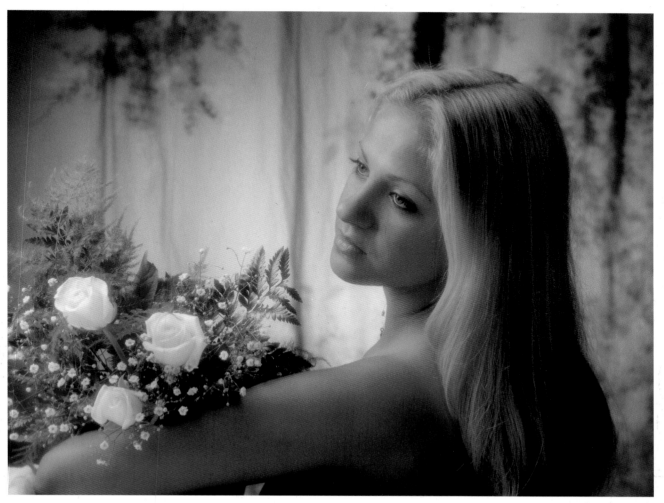

Facing page and above: Profiles must be handled delicately. The main light should be positioned so that a triangle of light appears on the left cheek.

earing to hide, and is also flattering for heavy subjects. Note that this placement of the main light will help you chisel out thinner-looking features.

Butterfly/Glamour Lighting. This is a somewhat flat type of lighting. It is often used in glamour shots, because it creates very light and open shadows that make the skin look very smooth and even. The shadow is under the nose

in the shape of a butterfly and it should not extend down into the upper lip area. If this happens, the light is placed too high and needs to be lowered to properly illuminate the face.

Rembrandt Lighting. This pattern produces a harsher style. The old masters used this style quite a bit in their paintings. Rembrandt lighting is similar to broad and short lighting

PARABOLIC LIGHTS

Parabolic lights with louvered doors—tin-style old-fashioned lights— should be used to produce profile lighting, Rembrandt lighting and split lighting. While these lights produce beautiful light, they are not very forgiving.

Right: In Rembrandt lighting, the long, dark shadow of the nose extends down to the corner of the mouth, leaving a characteristic triangle of lighter shadow on the subject's cheek.

Achieving proper exposure is extremely important, so a light meter is an essential piece of equipment for all portrait photographers.

in that the main light is placed at an angle to the subject, but in Rembrandt lighting the shadow areas are heavier. In fact, one side of the face is very dark. In this style, the shadow of the nose creates a long, dark shadow that extends down to the corner of the mouth, leaving a characteristic triangle of lighter shadow on the subject's cheek. This is a great lighting style for heavier clients, as it has a very slimming effect.

Split Lighting. This is similar to Rembrandt lighting, but the main light is placed directly to the side of the subject and, as a result, one side of the face is completely in shadow (it receives no illumination from the main light). This yields a high light ratio (the difference in brightness between the lighter and darker sides of the face). For example, the light side of the face may read F16, while the shadow side might read F4. This is a very unforgiving style of lighting that is not suitable for every subject.

► METERING

Because achieving proper exposure is extremely important, a light meter is an essential piece of equipment for all portrait

LIGHT RATIOS

A lighting ratio is a measurement of the difference in intensity between the main light (highlight side of the face) and the fill light (shadow side of the face). I think a 3:1 ratio is very flattering for both guys and girls.

photographers. There are two types of meters available: (1) incident meters, which measure the amount of light that falls on a subject, and (2) reflected light meters, which measure the amount of light that is reflected from the subject. Incident light meters are the type most commonly used by portrait photographers. There are many makes and models available: make sure your light meter is one that you can rely on and easily use.

There are many ways to achieve a reading, and the method you choose doesn't matter very much. What *is* important is that you consistently achieve good results. For incident meters, many photographers recommend that the photographer stand facing the light and measure the light that is directed toward the subject. When metering indoors, be sure to meter only one light at a time. For instance, when metering the main light, keep

the fill light and background light turned off.

Case Study. When working outdoors, shaded areas are ideal for portraits—whether they're taken on digital or traditional film cameras. We tend to meter the shadow area of the subject's face when shooting outdoors. A good shadow reading would be F5.6. Shooting at F5.6 causes the backgrounds to blur slightly, keeping the

focus on the subject. Because I want to emphasize the mask of the face, I adjust my lights until the mask—the highlight side—of the face reads F8. (On a sunny day, we might use an F8, F11 or even an F16 reading on the mask of the face.) When shooting a client in front of a running waterfall, showing the motion of the water is important. In order to achieve the correct exposure and capture the moving water, I have determined that I need to shoot with a $\frac{1}{30}$ second (or slower) shutter speed. With the highlight side of the face reading F5.6, and the shadow side reading F11, I have set up a 2:1 ratio.

When working outdoors, shaded areas are ideal for portraits—whether they're taken on digital or traditional film cameras.

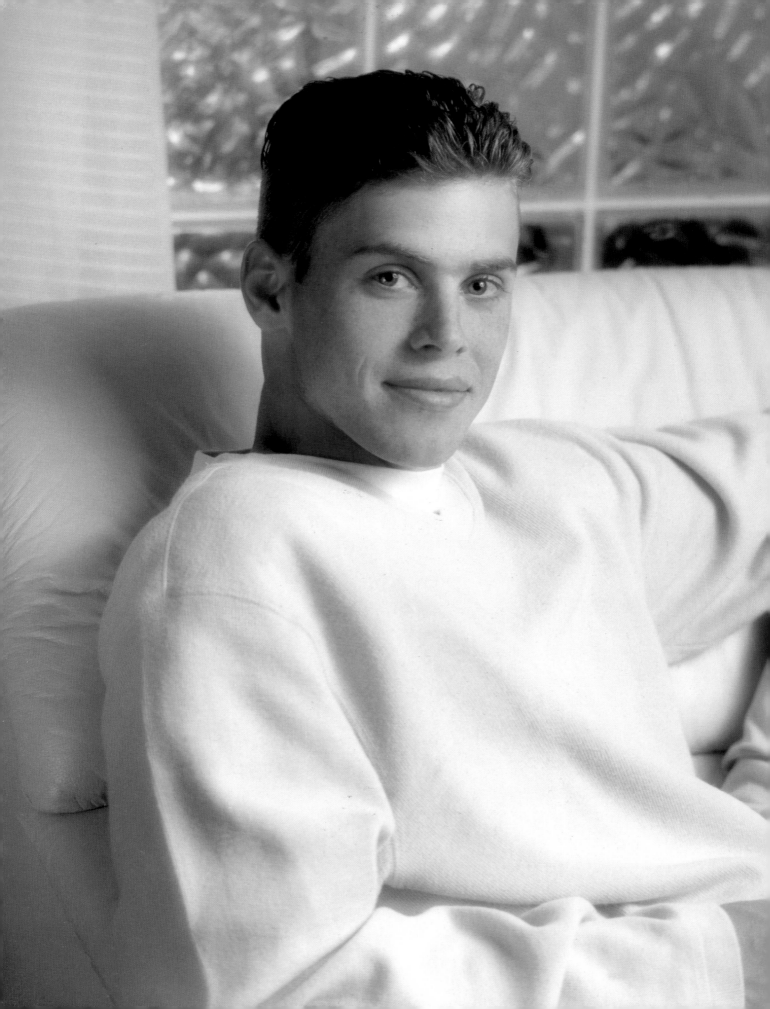

The term "key" is used to refer to the overall tonal range of an image. In high key portraits, all the tones are light. The subject wears light clothing, the background is white, and all props are light in color. White-on-white images—and a well-lit window in the background—are gorgeous for the girls (but avoid this style with overweight clients).

In low key lighting, the tones in the image are dark. Low key images are especially flattering for guys. I love photographing a student in black leather on a dark backdrop (with separation in lighting, of course). Sweaters that match dark backdrops look great. Blues on blues are really sharp. Both the high and low key lighting styles are very popular in our studio.

► AMBIENT WINDOW
LIGHTING

Natural light is a wonderful thing! A large bay window in your studio can be a great lighting tool. It helps with flash photography because when there is a lot of light your iris gets smaller, adjusting the amount of light that gets into your eye.

Facing page and this page (bottom left): High key photos feature a subject in white or very light clothes against a white background. This page (top and bottom right): Low key photos feature a subject in black or very dark clothes against a dark background.

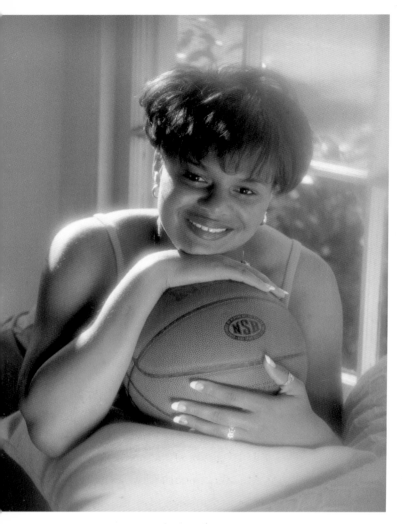

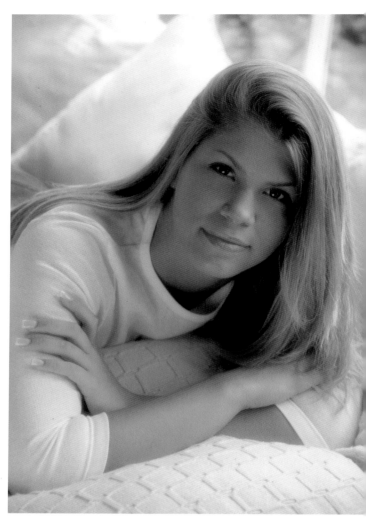

Above (left and right): Natural light can be combined with reflected light or flash for a soft and natural look. Left: Window benches can be put on wheels for easy movement and also used for storage.

When your subject's irises are smaller you can get more of their eye color in the shot.

► CAMERAS

Medium Format. I have found through the years that Bronica Tamron equipment is the workhorse of the trade. It is lightweight and able to fire with all lights. Bronica's ETRSI medium format bodies include 220 backs, 120 backs, 50mm lenses and 75mm lenses. The most widely used is the 100mm–200mm zoom lens (longer lenses are great for portraits and provide nice depth of field) with a #3 or #4 Tallyn filter. Tallyn makes four levels of softening filters, #1–#4, with #4 providing the maximum softness. The Nikon screw-on #2 filter provides great softening for images—it really helps to camouflage acne. Let your creative vision for the image dictate your filter selection.

Digital. I also currently use a Fuji S1 digital camera, which captures an 18MB file. This camera can be used to produce image sizes of up to 16" x 20". (A newer model, the Fuji S2, captures a 32MB file, and can be used to produce final images larger than 16" x 20".)

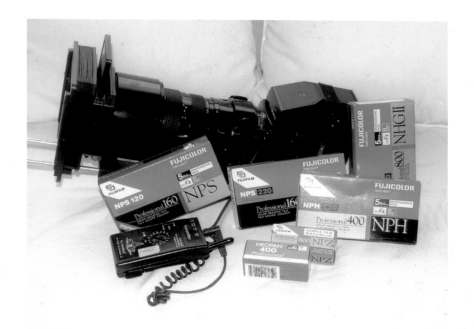

I have found through the years that Bronica Tamron equipment is the workhorse of the trade, and I feel that Fuji offers the highest quality films.

► FILM SELECTION

I have used various films over the years, and have found Fuji to offer the highest quality. I use several different types of Fuji film. They are as follows (all are available in both the 120 and 220 formats):

- NPS 160
- NPH 400
- NHGII 800
- NPZ 800

The 160ASA film can be used in the closed camera room with studio lights. I prefer the 400ASA films near the bay window or for outdoor use all day long. At 800ASA, the NHGII film should only be used when the lighting conditions are extremely dark.

Posing Basics

▶ HEAD AND SHOULDERS

Over the years, the typical head and shoulder pose has been the most requested when Mom places her senior's portrait package order. We tend to tilt the head a bit, and do not photograph our seniors with both ears showing.

Most yearbook advisors who work with contract photographers will require that both shoulders are visible in the portrait. Although these images must be shot head-on, angling the face by tipping the head to the left or right will give a beautiful eye-pleasing angle and remain within the yearbook's guidelines.

Tipping the head to the left or right will create a pleasing angle.

▶ ³/₄ AND FULL LENGTHS

When posing seniors, try to fully include the full extent of any portion of the body that falls into the frame. For

Left: It's the beautiful expression that will sell this head and shoulders pose! Right: This example of a young man in a suit is a beautiful headshot for Mom. Note the separation created by the background light.

Limbs

must be handled

very delicately,

or they can look

stiff and

posed.

instance, if you *can* include the hands in the pose, don't cut the image off at the wrists. In a ¾ pose, I tend to "cut" the pose where the elbow bends. Limbs must be handled very delicately, or they can look stiff and unnaturally posed.

When shooting seniors, you should always place the body and the camera in a way that will produce a more wholesome image. When the client is posing for a full-body seated shot, you can have him or her drop their arms into a V-shape so that particular ares are hidden. A lot of photographers don't

handle this issue with enough sensitivity.

Remember, the farther you pull the main light away from the subject, the more you have to increase its power. Because of this, you must remember to re-meter when you switch from the head shots to the ¾ and full-length shots. If you have an F11 reading of the subject when the the main light is three feet from his face, you'll need to either add light or open up your aperture to maintain this reading when the light is placed further away.

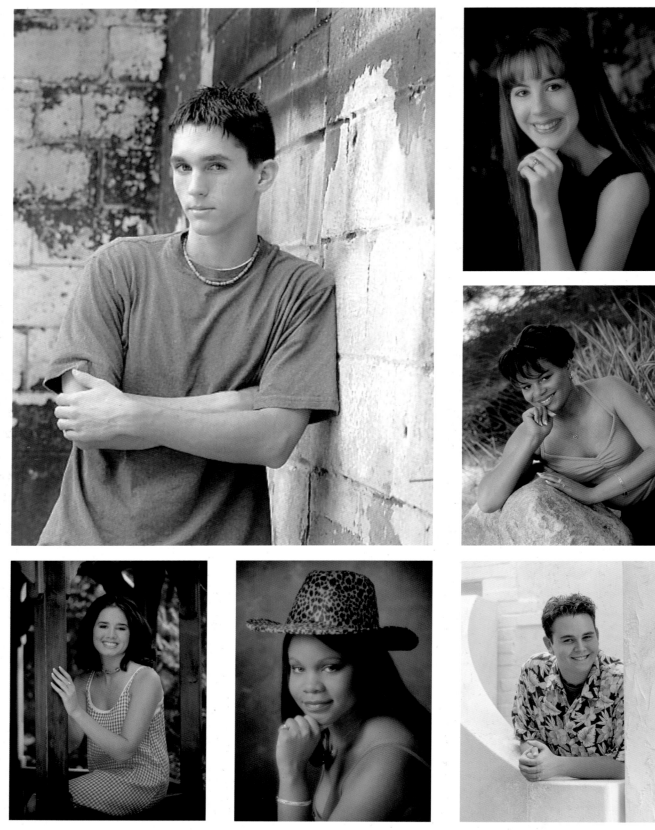

Above and facing page: Your subject's limbs and hands should never look stiff or distracting—strive for a very natural look.

► HAND POSING

"Arranging" the hands is the most delicate part of posing a senior. Hands must be graceful and should never distract the viewer's eye from the subject's face. When photographing girls, pose the hands so that the fingers are fanned under the chin, showing off the class ring. If nails are not well manicured, you can hide the fingernails by folding the fingers.

The hands and arms are the most masculine part of a guy. I like to position the hands as if they are holding a golf club, or in a fist. When positioning hands, always turn them away from or in toward the camera—but never straight toward the camera. Hands can also be placed in pockets, or positioned loosely gripping belt loops.

► HAIR

Sometimes posing is less a matter of carefully arranged limbs and more a matter of well-concealed problem areas. The hair can really work wonders here. If you have a heavy client—or one with a facial scar or other problem that can be easily concealed—you can arrange long, flowing hair in a way that really flatters the sub-

ject and veils problem areas. Always emphasize the clients' best features.

► GIRLS VS. GUYS

Over the years, I have developed my own style. Most customers will recognize "The Ellie Vayo Portrait." I tend to turn the guys' faces in toward the camera, tipping the head slightly toward the camera as well. The shoulders should also be turned at a slight angle to the camera—this creates a nice, masculine pose. Some of the most dynamic images of young men are not smiling, so if he won't smile, then don't try to get a forced expression.

For girls, avoid positioning the body so that it is straight on to the camera. Girls should be instructed to place their weight on their back foot—and the rest of the body should create a graceful S-shaped curve.

TIPS
• S-curves—Try to introduce S-curves into a portrait whenever possible, as this adds a nice dynamic look to the image.

• Galleries—Study the masters for posing ideas. Art galleries and art books that feature the works of top-notch painters will provide plenty of inspiration.

Creating Indoor Sets

► CHOOSING A BACKDROP

Selecting backdrops can be tiring and expensive. Should you purchase a painted canvas? Order a variety of muslins? Throughout my career, I have purchased many backdrops and spent a lot of money doing so. I have found that what works best for my small studio is a ten-foot painted canvas backdrop that I have used for over twenty years. It is great because I light it in different ways for different effects. I have also purchased muslins in several colors such as light tan, black, gray, brown, light pastels (upon which we project different colored gels), light blue, light gray, etc. Muslins are quite a bit cheaper than hand-painted canvas backdrops, so you can stock up and easily create a variety of looks for indoor sessions.

We've installed all of our muslins on a track system. This allows us to change a backdrop

Coordinating the backdrop color with the subject's outfit creates an eye-catching look.

and never get outdated. Among the props that work well for us are:

- Antique chairs
- Leather chairs (black & off-white)
- Posing tables
- Silk flowers (these are easily stored)
- Columns

A successful prop should be a positive element in the scene. It should never distract the viewer from the subject of the portrait—the senior. In other words, any props used should play a supporting role in the portrait.

▶ WINDOW LIGHT SETS

Having a north-lit window in the camera room is wonderful. But what if you don't have a large window in your camera room? Lumber stores carry bay window frames—without the glass. You can easily make a window set by using sheer curtains and putting your light source behind them to create the effect of sunlight filtering through the window all day long.

Having a north-lit window in my camera room is great,

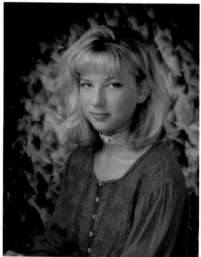
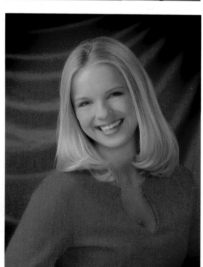

From painted canvases to waterbed sheets, offering a variety of backdrops helps you to create a variety of unique images for your clients—and keeps you from getting bored shooting the same thing day after day!

immediately to suit the color of the subject's outfit.

We've also experimented with a variety of "alternative" backdrops, most of which are quite inexpensive. I've found that waterbed sheets make beautiful backdrops for girls. Each year, we also purchase many new backdrops from a local fabric store. Doing so

allows us to keep exciting new backdrops on hand—ones that my competition will not readily find and duplicate.

▶ SELECTING PROPS

Due to the fact that storage is a major concern in the camera room, we don't stock a lot of props. The props that we do stock tend to be traditional,

because I treat the light coming from the window as my main light source, then I pull a silver reflector in to light the shadow side of the subject's face. I strive for an F8 reading at the side of the face nearest the window and F4 to F5.6 on the shadow side to get a beautiful, natural look. I usually use 400-speed film and I always shoot from high angles to help minimize distractions in the background.

Creating new sets is not only exciting for new seniors but also for yourself. Everyone gets tired of seeing the same thing over and over. Be creative! Have a wall in your camera room cut for a new window, or design an artificial light source. Not only are we photographers, remember we're also artists.

▶ CREATIVE LICENSE

Some students will have very clear ideas on what color the background should be, which props they'd like to use, etc. We try to work with the seniors, if possible, but again, as an artist, you must previsualize the scene and work the set to produce the most flattering image possible. When you build trust, you build a relationship

with your client—and that can only result in success for both of you.

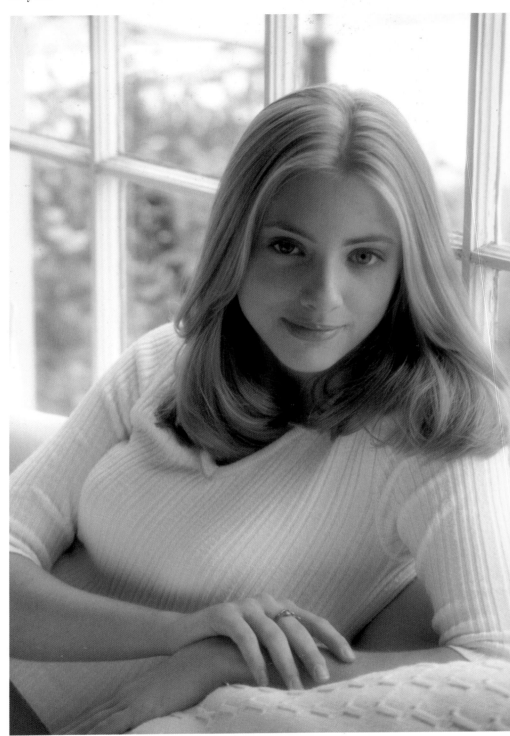

As an artist, you must previsualize the scene and work the set to produce the most flattering image possible.

Creating Outdoor Sets

▶ PLANNING

Before you decide to build even one outdoor scene for your studio, it is a good investment to hire a landscape architect to evaluate the space. When the building was purchased for Ellie Vayo Photography, the outdoor area was comprised of little more than weeds and unruly trees.

The first thing we did was contact a reputable landscape architect and create a plan for the acre. Planning is extremely important when it comes to designing your outdoor area.

Evaluating the Light. Since keeping up with your landscaping is an ongoing process and mistakes can be very costly, you'll want to do your homework before spending the cash. Take your camera out and look through the lens to check out the lighting at different times throughout the day. This will help you decide where to place your different settings, plants and trees.

Budgeting. As with everything, it is a good idea to set a realistic budget and stick to it. It's okay to develop your land over several years. If you are on a tight budget, put down a basic design and add to it each year. Outdoor landscaping is a great investment for your studio, and the creative possibilities are endless!

▶ BEACH SCENE

Because my studio happens to be ten minutes from the beach-

If you are on a tight budget, put down a basic design and add to it each year.

The obvious answer to the problems of shooting at the beach was to design a beach scene at the studio.

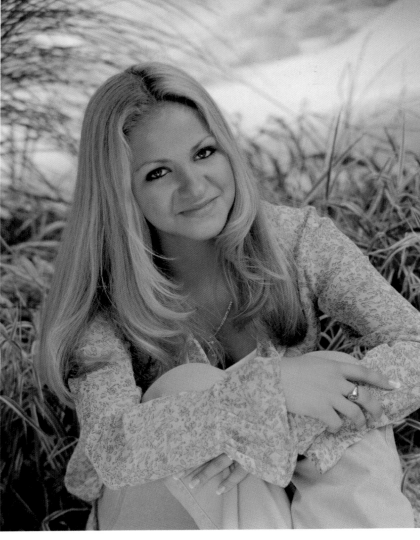

es of Lake Erie (yes, there are beaches!), the studio constantly received requests for on-location shoots at the beach. As most photographers know, the midday sun is too harsh for flattering photographs, and dodging spectators in a public area can be tricky. These problems are compounded by the travel time, which could otherwise be spent shooting additional sessions!

The obvious answer to us—and a great idea for studios all over the country—was to design a beach scene at the studio. The set will prove extremely profitable for your studio, and will eliminate the need to haul all your camera equipment to the beach!

Locale. Your beach scene should be sheltered from the hot midday sunlight with some kind of covering. The one we

use is covered with a 10' x 10' tent (the actual area is 15' x 12'). Any background elements, such as plants or trees, should act as a buffer and add a sense of dimension to the set. Boulders placed in self-draining stone (called pea stone) add a nice effect. Using the pea stone instead of sand also allows your seniors to walk away clean! Obviously, this set is great for families as well as seniors.

The roof of our three-sided barn scene is built from fiberglass panels, so it diffuses overhead light for a softer, more flattering lighting effect.

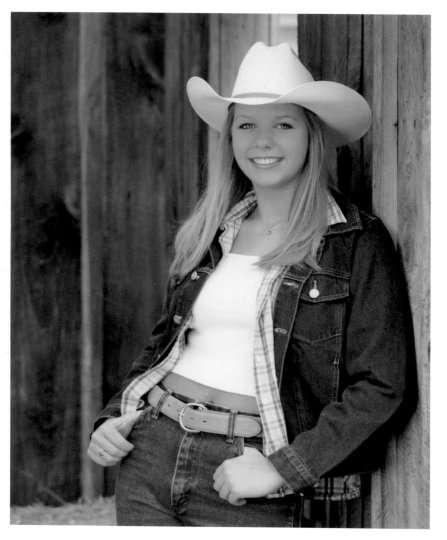

▶ BARN SCENE

If you follow your creative impulses, you'll often come up with some unique ideas for sets. At Ellie Vayo Photography, we created a barn that is furnished with haystacks, lanterns and a wagon wheel. We actually built this three-sided barn ourselves—from siding purchased at a home superstore (we used 4' x 8' panels for each of the three sides). The siding had great texture, and we improved it with wood stain. The elements have now taken a toll on the material—and it looks even better. The roof is built from fiberglass panels, so it diffuses overhead light for a softer, more flattering lighting effect.

The barn scene is really a great investment because it can be used year-round. An added benefit? The barn can be broken down and moved quite easily, and is quite inexpensive to construct.

The most popular set over the years has been the waterfall scene.

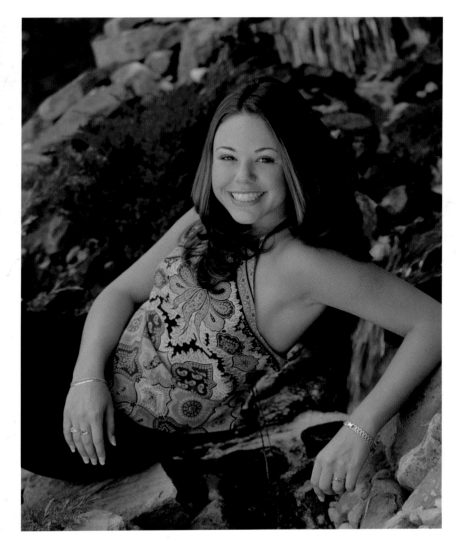

► WATERFALL

My studio offers twenty-five different outdoor sets. The most popular set over the years has been the waterfall scene. The waterfall is twenty feet wide and cascades down in three different levels, which start at seven feet in height. It was built using a kit from Aquascape Waterfalls. A rubber pool liner was set up and covered with rocks to give a natural pond look (we'll soon be adding plant life to further enhance the area). A pump at the base recycles the water all day. We've further enhanced the set by adding a bridge set purchased from Off the Wall.

► TRELLIS AND ARCH AREA

This inexpensive set was purchased through a catalogue called Domestications, which anyone can subscribe to. It is lightweight and can be easily moved from location to loca-

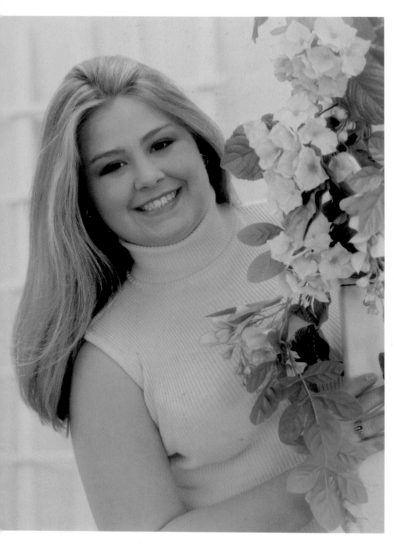

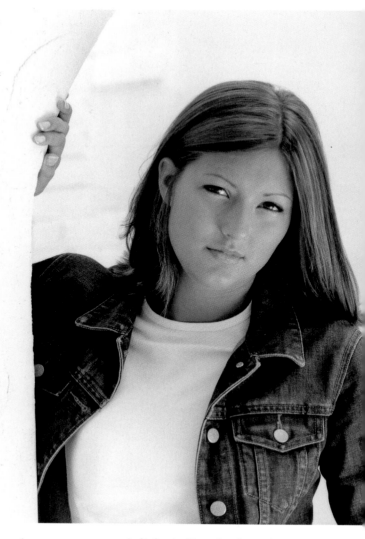

tion. It has proven to be very popular with senior girls. It's a great set in which to hide sleeveless arms.

The stucco arch area was easily constructed. A carpenter built the wooden arch, then covered it with stucco. It's a great architectural element, and offers a timeless backdrop for our sessions. In fact, the arch is great for both black & white and color pictures. A set from Off the Wall was used to give the illusion of a stairway entrance.

So many different sets can be created outdoors. Your studio should regularly add new scenes or modify old ones to create some variety in your shots. Get creative—after all, you don't want to get bored with your own settings!

Left: Our trellis and arch area has proven to be very popular with senior girls, and is a great set in which to hide sleeveless arms. Right: Our stucco arch area was easily constructed and offers a timeless backdrop for our sessions.

Backed with foliage, our wooden gazebo set is perfect for portraits with a casual, natural look.

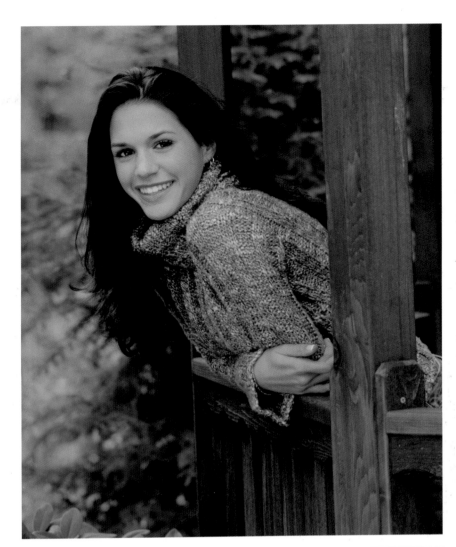

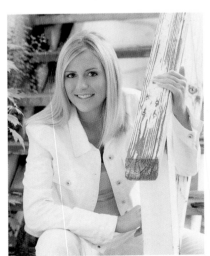

From weathered steps to stone walls, having a variety of sets available is a significant asset for a studio.

Outdoor Lighting and Equipment

One thing I have discovered through the years is that nervous clients really loosen up in front of the camera when they are outdoors. That is just another of the benefits of the outdoor session. At my studio, once the client walks outside, there are dozens of different lighting possibilities—as well as a wide variety of sets to choose from.

Lighting is extremely versatile outdoors. There are so many ways to make it work just the way you want it to—using reflectors, shades and awnings are just a few. The following images illustrate how flexible outdoor lighting can be.

► REFLECTOR FILL

Using reflectors is a great way to replace a fill flash on the camera. I prefer to use a silver reflector. While gold or white reflectors can also be used, silver does not wash out, and the lab seems to better color bal-

Clients really loosen up in front of the camera when they are outdoors.

ance the skin tones when silver reflectors are used. The great thing about reflectors is that they can brighten shadows, downplay dark undereye circles, bring out the eyes and totally enhance the portrait.

Don't feel that you have to limit yourself to one reflector. In addition to the fill reflector, you may want to use a reflector to block harsh sunlight. This may prevent you from capturing all the light that you actually need, but by having an assistant hold a silver reflector to direct remaining light where you want it, you can end up with a beautiful portrait even in the middle of a sunny day. (That assistant can be Mom, Dad or anyone accompanying your senior to the session!) Reflectors were used in all of the outdoor scenes shown in this chapter.

▶ FLASH FILL

When shooting groups of two or more—especially if you are using longer exposures outdoors—it is always a good idea

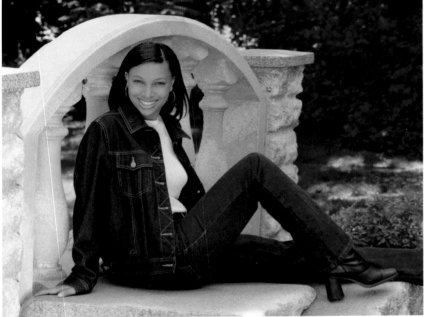

Reflectors will help you to block strong sunlight and/or bounce in fill light to open up shadows. This is particularly important when working outdoors where the sunlight can be quite harsh.

to use flash fill (either on the camera or off). If your ambient light reading is F8 at $^1/_{30}$ second, you will probably want to set your flash $^1/_2$–1 stop over. The camera reading could, in this situation, then be set for F11 (flash) at $^1/_{30}$ second. You really want to use a flash that can overpower the bright sunlight if need be. Always be prepared for different lighting conditions.

▶ BACKLIGHTING

Backlighting can be a beautiful way to light a subject—either indoors or out. Treat the sun like a main light by posing your subject to create highlights and shadows. Placing the subject with the sunlight to his back and filling in the frontal lighting with a flash fill or reflector can be very dramatic when executed properly. If your backlighting reads F22, you will want to front fill with a flash of F16. It's such a shame when you see a subject with beautiful backlight but the photographer has neglected to light his face properly.

▶ AWNINGS

Awnings can work wonders outdoors. Not only will they keep the effect of the elements down to a dull roar, but they also

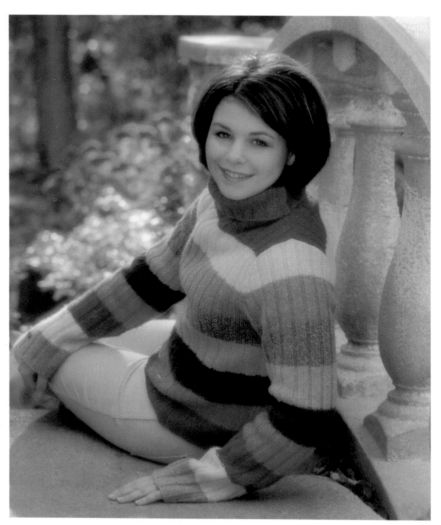

Backlighting with rim light on the shoulder creates a soft, warm effect in this outdoor portrait.

block harsh overhead light, allowing you to add it in with reflectors or your flash. We actually had one very heavy rainstorm last year that might have proven really problematic for most photographers. We simply set the camera on a tripod, placed a large umbrella overhead and used our covered outdoor sets!

After the Session

► WORKING WITH A LAB

It's very important to develop a good working relationship with your lab. You should familiarize yourself with their pricing and guidelines so that you can structure your price list according to their unit pricing. You'll want this studio–lab marriage to run smoothly. In order to ensure a happily-ever-after relationship, there are a few questions you'll need to ask yourself and your lab representative:

1. Can you handle our volume? If the lab you want to deal with doesn't answer their phone right away or cannot return phone calls, you'll really want to reconsider using them.
2. Is their color consistent?
3. Are they overpriced?
4. Do you get along with the sales rep?
5. What type of payment plans do they offer and do they offer volume discounts or rebates?
6. Do they offer free shipping to and from the lab?

Digital Questions. With the digital photographic industry changing on a daily basis, be sure the lab can retouch digitally. Be sure to find out what type of digital equipment they use. You'll also want to determine how the digital revolution will affect the operation of your lab in the future.

We really try to send all of our printing to one color lab. Doing so offers many advan-

You'll want this studio–lab marriage to run smoothly.

tages: we know the staff that will be handling each of our images, the quality we can expect, and the volume they can handle.

► PRESENTING PREVIEWS

There are several ways to deliver previews. Whether you choose to use folios or small or large albums, the presentation of your product is very important. Packaging is something the client will always remember. There are several companies that supply albums, folios, etc. Some of the better-known companies include:

• General Products

• Albums Inc.

• Art Leather

While we used to use eight-pose folios and provide the client with a separate pricing guideline, I have found that using the Ellie Vayo album has worked best.

The Ellie Vayo Senior Album. Various means have been used to present previews to clients. One of the most successful presentations thus far has been my "Ellie Vayo Senior Album," which I developed

CONSISTENT COLOR

Sometimes when we get images back from our lab, they appear somewhat washed out. This is obviously a problem—as artists, we want our colors to really pop. We want our blues to be rich, and our reds to be intense. Every lab offers a "ring around"—a series of images printed in a variety of ways. These "readings," called lab density readings, will help you to determine whether any problems you encounter lie in processing or in exposure. To use the readings, compare the density reading on the back of your proof with the normal density reading, which your lab can provide. This simple step will help you and your lab produce images that are pleasing to you, and will help you identify whether any errors are due to processing problems or improperly exposed negatives.

with General Products. In the past, paper previews were delivered in folios. The downside was that they were delivered with a separate price sheet that was easy for the client to lose. As a result, the client would come in unprepared, so it took longer to place an order. This obviously cut down on the number of available appointments per day. The Ellie Vayo Senior Album is a cohesive sales tool. It displays everything that the studio offers to seniors—from packages, to retouching services, to cluster collages, to announcements (and yes, even folios!). It also serves as a record of the senior's final year in high school and, for photographers

who use it, the Ellie Vayo Senior Album has increased sales averages by over $100 per order.

Here's how it works: the Ellie Vayo Senior Album comes complete with all pricing information, the student's school yearbook deadlines, copyright information, answers to some frequently asked questions, frames, mats and other add-ons and the client's previews—usually twenty-four to thirty images—all in one bound album. This allows the client to show it off to friends and family, thus creating more orders and also giving you some additional advertising! A $200–$300 deposit should be put down on the album before the

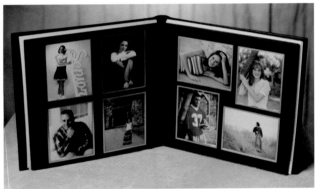

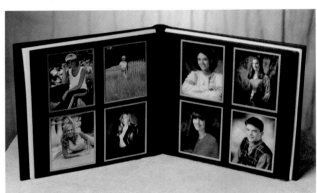

The Ellie Vayo Senior Album is a cohesive sales tool. It displays everything that the studio offers to seniors—from packages, to retouching services, to cluster collages, to announcements (and yes, even folios!).

TIPS

• **Questionnaire**—We also include a questionnaire in our albums. It allows the senior to offer feedback about their experience, and helps the studio provide excellent service by anticipating and meeting the changing needs of our clients.

• **Cost**—It used to cost $8.00–$10.00 to put together an eight-pose folio for our clients. When the Ellie Vayo Senior Album is assembled in the studio, that cost jumps to only $21.00 per album. Because we can charge a lot more money for an album than a folio, our profits have grown quickly with the introduction of the album!

client leaves the studio with it. That deposit will ensure the safe return of the album—hopefully with a large order and purchase of the album!

To assemble the albums in your studio, you can purchase a spiral binding machine from any office supply store. General Products sells the album, plastic coils, and all styles of mats in different sizes. Add your own

personalized pricing information and any additional pages you want included for your studio. It is a good idea to have your staff assemble the albums in the slow winter months so that they are ready when senior season comes around. Deliver the album in a decorative box (people love presents!) or canvas bag with your logo on it. Remember, presentation is almost everything!

We sell 75 percent of our albums to clients. The remaining 25 percent that are not purchased are returned, and can then be stripped and refilled with updated pricing information, new photos, etc.—and passed on to another client!

▶ PACKAGES

We have found that packages are the best bet for our clients. We offer about five different packages. Our most popular is the five-pose package, because the kids really want the variety. We also offer one-pose, three-pose, and seven-pose packages. Additional poses are available at an additional charge.

Upon arrival, the client can select the sizes he or she wants—wallets, 8" x 10" prints, etc. We've found that wall por-

It is a good idea to have your staff assemble the albums in the slow winter months . . .

traits—the 16" x 20" and 20" x 24" prints—are very popular with the parents. We then mat and frame the images so they're ready to be displayed in the home. The Ellie Vayo Senior Album is also included in many of our packages. As noted above, we sell about 75 percent of the albums we put together!

► RETOUCHING

A retouching/color balancing charge is added to all of our packages. Generally, the retouching is free for the first image, and a charge is applied for each additional image. With really large orders, we sometimes add the retouching in for free.

► FRAMES

At Ellie Vayo Photography, we offer a full selection of frames: a custom line, and a more general line, which is included in three of our packages. The client can upgrade to our custom line, which includes mats.

We try to market the frames at the point of sale. We place the various moldings directly against each preview to show our clients how great each image will look with a frame.

► VARIETY = BIGGER SALES

We have found that, if the images are spectacular, the customer will probably want all of them! After all, how can a parent part with such precious pictures of their child? It is important to offer *many* different sets—never shoot two portraits on the same set! Different sets mean bigger sales in the end.

When you have a client whose biggest problem is that they just can't decide which pictures to eliminate from a package, you know you have done your job as an artist! That "problem" proves a point—it is important that your studio offer add-ons to any package. You should strongly consider offering clients an option to add an extra pose to any package for $15 or $20 (plus any additional retouching cost). Chances are, this won't be an inconvenience to your studio, because the client won't actually be getting any more pictures in their package, just more poses. Offering it will only add to your profit.

TIPS

• **Black & white**—Make black & white images available to your clients, as they tend to be a real hit. Images can be converted from color to black and white in a snap with an image-editing program like Photoshop®. These "new" images make great add-ons!

• **Packages**—Work with your lab to determine the cost-effectiveness of a package. For instance, most color labs offer three- and five-pose packages. It makes good business sense, therefore, to offer the same packages to your clients.

Digital Imaging

▶ ADVANCES

As a professional, I have always upheld the quality of images that I get from film. I never thought I could offer digital images to my high-end clients who have always paid top dollar for the art that we give them.

Today, that has changed. Digital has made some tremendous advances, and the quality, cost and speed at which you can produce these images is constantly improving. To stay on top in this profession, it is important that you stay current on trends in the industry. Now is the time to learn—or brush up on—the digital skills you'll need to stay competitive.

Take your time and learn about the digital market, then take small steps. For example, first train your staff in the use of Adobe® Photoshop®, an important digital retouching program. Then, get some equip-

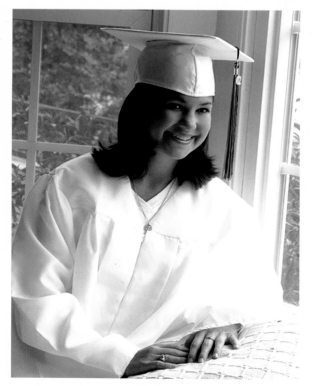

For our cap 'n' gown special, clients were able to pose for their portrait, see it, and purchase it—all in one sitting.

Quality equipment is key to producing quality digital images.

ment; a scanner should be the first piece of equipment you purchase. A quality scanner is a great start and, with prices dropping every day, won't empty your bank account.

► CAMERA SETTINGS

Digital is different from film as far as camera settings are concerned. The camera has different sensitivity settings that correspond to the ASAs of film—

400, 800, 1600, etc. I set the camera at 400 for portraits taken both in the camera room and outdoors.

► SELECTING EQUIPMENT

When selecting a computer to use for digital retouching, look for a model equipped with the following features:

• High-speed processor
• CD-ROM drive

This year alone, digital photography has paid for the cost of all the digital equipment we purchased—and then some.

- Floppy disk drive
- High quality monitor (the size should be 17" or larger)
- Large hard drive (we use a 20G drive)

We have installed Adobe® Photoshop® (version 7) on our main imaging computer and also on a laptop that is used on location. We complete all of the retouching for our digital images in-house.

▶ SCANNERS

Scanners are used to convert images on traditional media (slides, negatives and prints) to digital files. When selecting a scanner, look for equipment that accommodates all of the media you use and all the formats. For example, if you shoot both 35mm and medium format negatives, you'll want to make sure to purchase a multi-format scanner that can handle both sizes. If your lab will be printing your digital images, you should consult with them about their needs for outputting your files, and make sure that your new equipment will meet or exceed those needs. If you plan to print your images yourself, review the

user's manual for the printer you plan to use and make sure that your scanner can produce digital files that are of a sufficient resolution.

► PRINTERS

At Ellie Vayo Photography, we use the Olympus P400, which is a dye sublimation printer that is used for images up to an 8" x 10" size. It's really a great desktop printer—and it produces true continuous tone images.

Many photographers like to use inkjet printers which can also produce stunning art prints and watercolor notepads. Both Hewlett Packard and Epson printers work well.

► DIGITAL SPECIALS AND SERVICES

Digital equipment lends itself nicely to many portrait specials—the applications for your studio are endless. For example, our studio shot a "cap 'n' gown" special using the Wein Safe Sync Voltage Regulator. (The Wein Safe Synch Voltage Regulator is a device available through Fuji that protects against blown out portions of an image. It is placed on the hot shoe, then attached via a power cord to studio lights.) For this special, clients were able to pose for their portrait, see it, and purchase it—all in one sitting. The special generated over $1,000 in one day—and there were no film or lab costs.

In addition to specials like the "cap 'n' gown" one, your studio can offer the following digital services:

- Digital passports
- Digital holiday pictures
- Sports action photography on-line through a web site
- Model portfolios
- Instant yearbook glossies for last-minute senior portraits
- Photos for real estate and newspaper publications
- Special event pictures— ready by the end of the event!

This year alone, digital photography has paid for the cost of all the digital equipment we purchased—and then some.

As far as what events we choose to use digital for, we have taken digital in steps. For our studio, digital has turned out to be extremely profitable, easy and fast. If you are apprehensive about introducing it into your studio, just remember to take it slow and learn all you can about how to make it work for you. You will probably find that switching some of your business to digital will make your job go much more smoothly!

SHADE

Shooting in shade is your best bet as it allows you a great deal of control over the lighting. Shooting digitally is much like shooting slide film—there is very little room for error.

Conclusion

▶ THE FUTURE OF SENIOR PHOTOGRAPHY

Senior photography is a competitive business. To stay on top, you'll need to keep up with the many changes that the digital revolution has in store. Of course, you'll need to juggle this acquisition of knowledge with another type of learning: you'll need to acquire great business skills.

The mom and pop business of the past are gone. These days, people are looking for more than a simple portrait from their photographers—they're looking for art, top-notch customer service and for something a little out of the ordinary.

Today, studio owners are more self-sufficient than ever. We're building our own props, retouching our own images, marketing every chance we get, and doing the framing and matting, too. We're adding to our bag of tricks—experimenting with various techniques, trying out new equipment, and exploring the "what ifs" We're getting business degrees to learn how to best manage our businesses and, every day, we're reaching more and more clients. As artists and technicians we're in a special place— we're in the business of preserving memories.

Contacts and Suppliers

► ELLIE VAYO SENIOR ALBUM

For a representative, call:
General Products
(800)888-1934

► WATERFALL KIT

www.aquascapedesigns.com

► BRIDGE SET

Off the Wall Productions Ltd.
(800)792-5568

► COLOR LAB

Buckeye Color Lab
(800)433-1292

► CAMERAS AND LENSES

Bronica/Tamron
(800)827-8880

► LIGHTING

Photogenic
(800)682-7668

► PROFESSIONAL ORGANIZATIONS

Senior Photographic International
PO Box 07399
Ft. Meyers, FL
www.seniorphotog.com

► PROMOTIONAL POSTCARDS

ABC Pictures
1867 E. Florida Street,
Springfield, MO 65803-4583
(800)433-1292

► SENIOR MAILER

Winona Printing Company
1117 E. Mark St.
Winona, MN 55987
(507)454-4410

► ON HOLD MARKETING

JBC On Hold Marketing
Jim Fiorta
(440)974-5121

► CLIENT DATA AND CUSTOMER SATISFACTION CARDS

Marathon Press
(800)228-0629

► SENIOR ALBUM BAGS (CANVAS)

Enviro Tote
(800)TOTE-BAG

► CDS, BUSINESS CARDS AND PORTFOLIOS

Media Post
www.mediapost.com

► CD SLEEVES, LABELS

Citiscape Ltd.
(800)473-4791
www.cardiscs.com

► T-SHIRTS FOR SENIOR MARKETING

Minds Eye Graphics
(800)942-9518

► GRADUATION ANNOUNCEMENTS

Stylart
(208)359-1000

► GIFT BOXES

N. P. D. Box Company
(800)969-2697

► WALLET BOXES

Tyndell
(800)827-6278

► STUDENT MAILING LISTS

American Student Lists
(516)248-6100

► MEASURING TAPES, POST-IT® NOTES

JII Sales Promotions
(614)622-4422

► TRELLIS AND PLANTER PROPS

Domestications
(800)746-2555

► PLASTIC COLUMN PROP

Pro Studio Supply
(800)558-0114

For more information on Ellie Vayo Photography, visit the studio web site at www.evayo.com.

Index